NIKON D40 & D40x

THE EXPANDED GUIDE

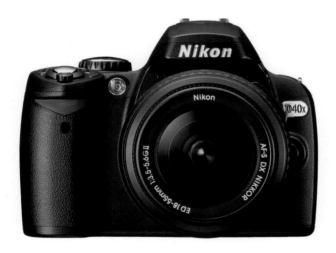

Ross Hoddinott

photographers'
pip
institute press

NIKON D40 & D40x

THE EXPANDED GUIDE

Ross Hoddinott

photographers'
pip
institute press

First published 2007 by
Photographers' Institute Press/PIP
an imprint of The Guild of Master Craftsman Publications Ltd,
166 High Street, Lewes, East Sussex BN7 1XU

ISBN 978-1-86108-517-7

British Cataloguing in Publication Data. A catalogue record of this book is available from the British Library.

Production Manager: Jim Bulley
Managing Editor: Gerrie Purcell
Project Editor: Rachel Netherwood
Managing Art Editor: Gilda Pacitti
Design: Fineline Studios

Typefaces: Frutiger and Sabon
Colour reproduction by Altaimage
Printed and bound: Hing Yip Printing Co. Ltd

Contents

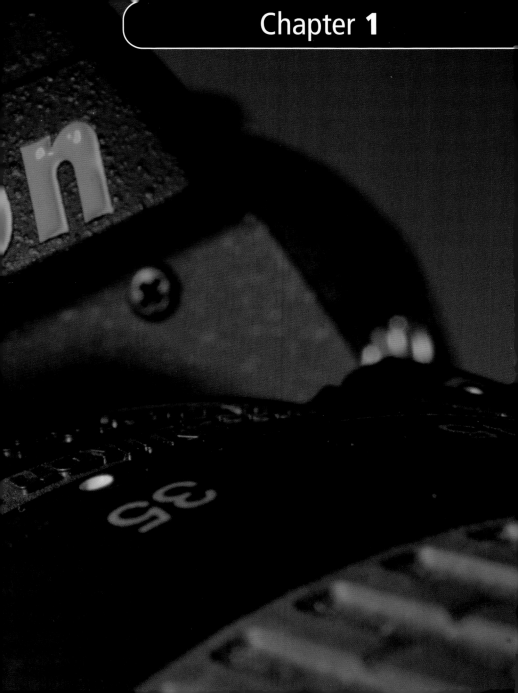

Introduction to the
Nikon D40 & D40x

The Nikon D40 & D40x are entry-level digital SLR (single-lens reflex) cameras. They are designed to entice beginners, or present compact users, to switch to the flexibility of a DSLR system – where the creative possibilities are simply endless.

Ever since producing its first camera – the Nikon I – in 1948, Nikon has been regarded as one of the world's leading manufacturers of cameras and high-quality optics. Nikon embraced the digital revolution

in the mid-1990s with the launch of its first digital single-lens reflex camera: the E2s. It was produced in cooperation with Fujifilm and based, in part, on the popular Nikon F-801s film body. The E2, a lower-spec model, was produced at the same time. Both cameras had a sub-35mm, 1.3-megapixel sensor, but maintained lens focal lengths via a series of reduction optics. In 1999 Nikon replaced its E series of digital cameras with the launch of the D1. This ground-breaking DSLR not only boasted a larger 2.7-megapixel CCD (charged

2001 – Nikon D1X and D1H
Nikon shook the digital world with the launch of two new cameras, each based on the D1, but aimed at different parts of the professional market. The D1X boasted a higher resolution, with a 5.3-megapixel sensor, whilst the D1H could capture speeds of five frames per second for up to 40 consecutive shots.

2002 – Nikon D100
Modelled on the popular F80/N80 film SLR, the D100's comparatively low price tag helped open up digital SLR photography to a wider market. The D100 was the first Nikon camera to incorporate a 6.1-megapixel sensor that offered users comparable quality to professional-standard transparency film.

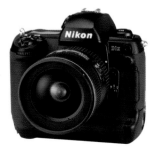

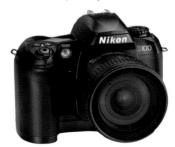

coupled device) sensor, but also abandoned the bulky reduction optics of the earlier E series. This significant redesign meant that the effective focal length of the lens attached was multiplied by a factor of 1.5. The D1 helped pave the way for the present generation of high-spec, high-resolution Nikon DSLR cameras, which prove so popular among amateurs, enthusiasts and professionals alike.

Nikon DX Format CCD

At the hub of every digital camera is its image sensor. The D40 employs a 6.1 (effective) million pixel 23.7 x 15.6mm DX-format CCD sensor; whilst the D40x has a larger resolution – incorporating

a 10.2 (effective) million pixel 23.6 x 15.8mm CCD DX-format chip. Both models boast Nikon's advanced image-processing engine and image-optimizing functionality, allowing the camera to capture images with sharp detail and faithful, vivid colour. The CCD chip incorporates high-speed four-channel data output. It also features an optical low-pass filter, which significantly reduces the occurrence of moiré and colour fringing. By combining colour-independent preconditioning, prior to analogue-to-digital conversion, with advanced digital image processing algorithms, it delivers fine colour gradations. Like all current Nikon DSLRs,

2004 – Nikon D70

The award winning D70 was one of the first cameras to make high-quality digital SLR photography accessible to all. The picture quality achieved from its 6.1-megapixel DX-format CCD sensor appealed to enthusiasts and professionals alike.

2005 – Nikon D50

Nikon launched the D50 as an ideal and affordable introduction to digital SLR photography. It was smaller and lighter than the D70 but with many of its bigger brother's qualities and features, including its 6.1-megapixel DX format CCD sensor.

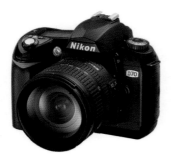

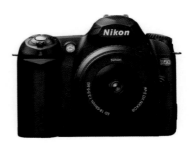

the sensors employed in the D40 & D40x are APS-C sized. As a result, the effective focal length is magnified by 1.5x – compared to use on a 35mm frame.

Whilst the D40x may possess a larger pixel count, both the D40 & D40x boast a resolution more than capable of satisfying the demands of entry-level and amateur photography. With a maximum image size of 3,008 x 2,000 (D40) or 3,872 x 2,592 pixels (D40x), both cameras are capable of delivering high-quality images and support detailed enlargements and large print reproductions.

About the Nikon D40 & D40x

Nikon launched the D40 in November 2006; 18 months after launching the D50 – its first truly entry-level compact DSLR. Despite its low price tag, the D40 is bursting with useful features. It boasts technology handed down by the D80, including 3D Colour Matrix Metering II, high-precision image-processing algorithms and image-optimizing features.

Launched in March 2007, the D40x is a variation of the D40. It is identical in almost every way, but with some useful refinements. Firstly, the D40x has an enhanced resolution of 10.2 (effective) megapixels. It boasts a lower base sensitivity of ISO 100, the auto ISO option includes ISO 200, and it has a faster continuous shooting burst rate of 3fps (frames per second).

The D40 & D40x are supported by an extensive system of lenses, flash units and other accessories.

Nikon D40 & D40x The Expanded Guide is designed to guide you around the camera as well as the Nikon range as a whole.

Tips
To download Nikon firmware or correspond with Nikon, you will need the serial number, which is on the underside of the D40 & D40x. The serial number should also be quoted on insurance documents.

Main features

Sensor D40: 6.24 million total pixels (6.1MP effective) Nikon DX-Format RGB CCD image sensor; 23.7 x 15.6mm (APS-C size); maximum image size 3,008 x 2,000 pixels. **D40x:** 10.75 million total pixels (10.2MP effective) Nikon DX-Format RGB CCD image sensor; 23.6 x 15.8mm (APS-C size); maximum image size of 3,872 x 2,592 pixels.

Focus Four focus modes: Single-servo AF (AF-S), Continuous-servo AF (AF-C), Automatic AF-S/AF-C (AF-A) and Manual focus (M). AF area mode can be selected from three focus areas: Single Area AF, Dynamic Area AF, Dynamic Area AF with Closest Subject Priority. Focus can be locked by pressing the shutter-release button halfway (single-servo AF) or by pressing the AE-L/AF-L button. Autofocusing only available with AF-S or AF-I lenses.

Exposure metering Three metering methods are available. In 3D Colour Matrix Metering II (type G and D lenses), the 420-segment RGB sensor sets the exposure based on a variety of information from all areas of the frame. Standard Colour Matrix Metering II is available for other CPU lenses. Centre-weighted and spot metering can also be selected. There are four exposure modes: Programmed auto (P) (with flexible program), Shutter-priority auto (S), Aperture-priority auto (A) and Manual (M). Exposure compensation can be set to between +/–5EV in 1/3 step increments.

Buffer Capable of shooting at 2.5fps (D40) or 3fps (D40x) in Continuous shooting (C) mode – 1fps with HI 1 sensitivity – in bursts of up to 9 NEF (RAW) frames. Continuous shooting in JPEG is only limited by storage. Other shooting modes available: Single frame shooting (S), Self-timer, Delayed remote and quick-response remote.

Built-in flash The built-in flash has a guide number of 17 (ISO 200/m). Automatic pop-up is activated in Auto and Vari-program modes. Manual pop-up is required in P, S, A or M modes. There are four flash-sync modes: Auto flash, red-eye reduction, slow sync and rear curtain sync. Flash exposure compensation can be set to values between –3 to +1EV in 1/3 steps.

LCD The large, high-resolution 2.5in, 230,000-pixel polysilicon TFT (thin film transistor) colour liquid-crystal monitor means finer detail is easier to view on screen. It provides access to the information display, changes to settings, menus and playback functions, with brightness/backlight adjustment.

Custom functions There are 17 useful, well-organized custom functions.

System back-up AF-S, DX, VR and D-/G-type lenses with full functionality. SB-series speedlights with i-TTL flash and SB-R1 wireless speedlight system.

Full features and camera layout

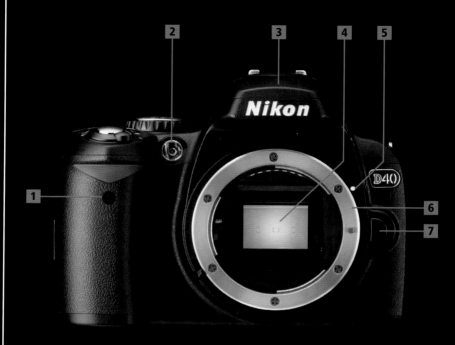

FRONT OF CAMERA

1 Infrared receiver

2 AF-assist illuminator/self-timer lamp/red-eye reduction lamp

3 Built-in flash

4 Reflex mirror

5 Lens mount index

6 Lens mount

7 Lens release button

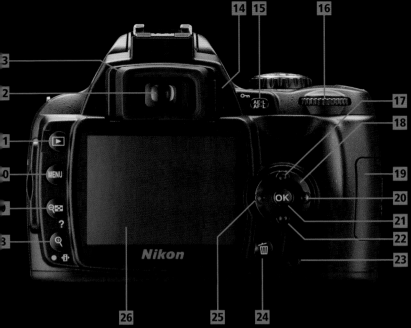

BACK OF CAMERA

8 Playback zoom/setting/
reset button

9 Thumbnail/help button

10 Menu button

11 Playback button

12 Viewfinder eyepiece

13 DK-16 viewfinder eyepiece cup

14 Dioptre adjustment control

15 AE-L/AF-L/protect button

16 Command dial

17 Up/view more photo info/
move cursor up

18 Multi-selector

19 Memory card slot cover

20 Right/view next photo/
display submenu

21 OK/retouch photo/
make selection

22 Down/view more photo info/
move cursor down

23 Memory card access lamp

24 Delete button

25 Left/view previous photo/
return to previous menu/cancel

26 LCD monitor

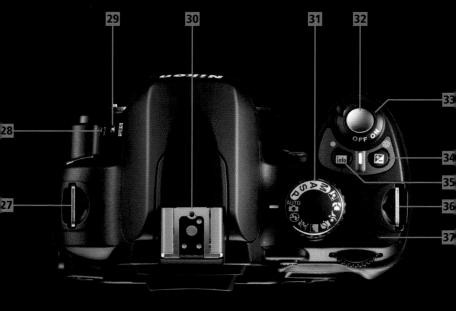

TOP OF CAMERA
27 Camera strap eyelet
28 Self-timer/function button
29 Flash mode/flash
compensation button
30 Accessory hotshoe
31 Mode dial
32 Shutter-release button
33 Power switch
34 Exposure compensation/aperture/
flash compensation button
35 Shooting information/
reset button
36 Camera strap eyelet
37 Focal plane mark

RIGHT SIDE
41 Memory card
slot cover
42 AC power cord
connector cover

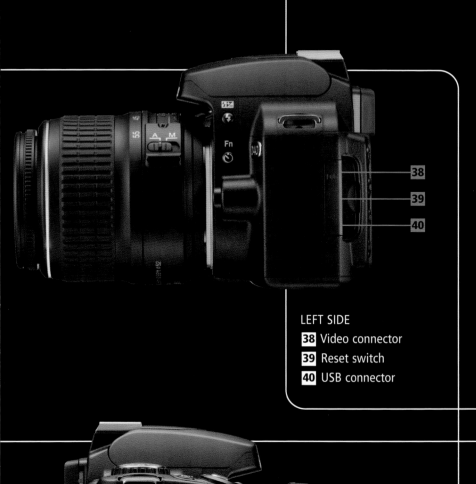

LEFT SIDE

38 Video connector
39 Reset switch
40 USB connector

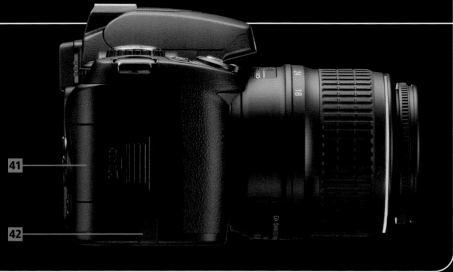

Viewfinder display

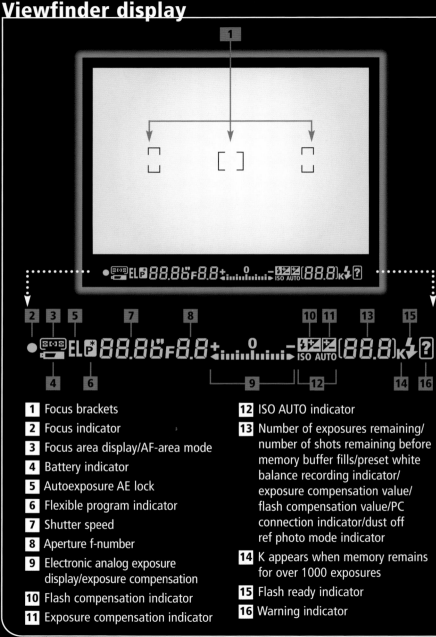

1 Focus brackets
2 Focus indicator
3 Focus area display/AF-area mode
4 Battery indicator
5 Autoexposure AE lock
6 Flexible program indicator
7 Shutter speed
8 Aperture f-number
9 Electronic analog exposure display/exposure compensation
10 Flash compensation indicator
11 Exposure compensation indicator

12 ISO AUTO indicator
13 Number of exposures remaining/ number of shots remaining before memory buffer fills/preset white balance recording indicator/ exposure compensation value/ flash compensation value/PC connection indicator/dust off ref photo mode indicator
14 K appears when memory remains for over 1000 exposures
15 Flash ready indicator
16 Warning indicator

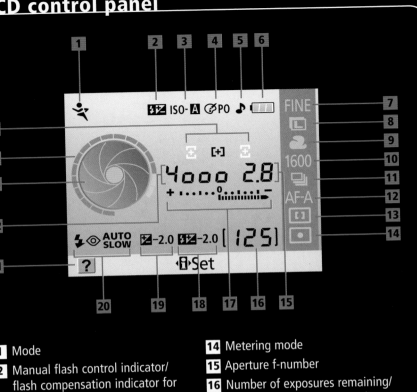

1 Mode
2 Manual flash control indicator/ flash compensation indicator for optional Speedlight
3 Auto ISO sensitivity indicator
4 Optimize image indicator
5 Beep indicator
6 Battery indicator
7 Image quality
8 Image size
9 White balance mode
10 ISO sensitivity
11 Shooting mode
12 Focus mode
13 AF-area mode

14 Metering mode
15 Aperture f-number
16 Number of exposures remaining/ preset white balance recording indicator/PC mode indicator
17 Electronic analog exposure display/exposure compensation
18 Flash compensation value
19 Exposure compensation value
20 Flash sync mode
21 Help indicator
22 Shutter speed
23 Aperture display
24 Shutter speed display
25 Focus area display

Menu displays

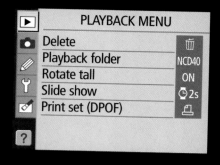

PLAYBACK MENU
Delete
Playback folder
Rotate tall
Slide show
Print set (DPOF)

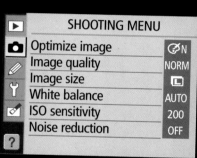

SHOOTING MENU
Optimize image
Image quality
Image size
White balance
ISO sensitivity
Noise reduction

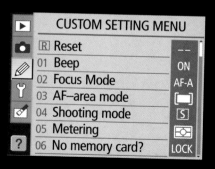

CUSTOM SETTING MENU

Reset	ISO auto
Beep	Fn button
Focus mode	AE-L/AF-L
AF-area mode	AE lock
Shooting mode	Built-in flash
Metering	Auto off timers
No memory card?	Self timer
Image review	Remote on
Flash compensation	duration
AF-assist	

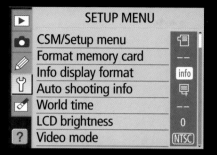

SETUP MENU

CSM/Setup menu Language
Format memory Image comment
 card USB
Info display Folders
 format File no. sequence
Auto shooting Mirror lock-up
 info Firmware version
World time Dust off ref photo
LCD brightness Auto image
Video mode rotation

RETOUCH MENU

D-lighting
Red-eye correction
Trim
Monochrome
Filter effects
Small picture
Image overlay

Chapter **2**

Operational guide to the Nikon D40 & D40x

At first glance, the large number of dials and menu choices available on the D40 & D40x can seem quite intimidating. However, don't be tempted simply to set the camera to Programmed Auto mode. If you do, you will never realize the camera's full creative potential. For this reason, in this chapter we are going to focus on getting you familiar and comfortable with operating the camera and customizing it to suit your own style and needs. However, before looking at mastering some of the more creative controls, you first need to learn the basic camera operations.

Finding your way around the D40 or D40x is far easier than you might expect. The layout and design is intended to be user friendly. Therefore, if this is an upgrade from a compact camera, and you have never handled a digital SLR before, fear not; you have made a wise choice purchasing this particular model. Before long you will find that every button and dial has a natural place and function. With this PIP Expanded Guide, and a little time and patience, you will soon be familiar with the camera and its many uses.

BABY GIRL
If you begin taking pictures without
fully understanding your camera you
will never realize its full capabilities.

Camera preparation

Mounting and detaching lenses, installing batteries and inserting and ejecting SD (Secure Digital) memory cards might seem basic enough, but if you ever have to perform these tasks under pressure, then you will find that practising in advance pays dividends.

Attaching the strap

Before using your Nikon D40 or D40x, attach the AN-DC1 strap supplied by feeding one end through the camera strap eyelet from the bottom – ensuring that the neck padding is facing inwards. Pass it through the buckle of the strap and pull it firmly until any slack is taken up. Carefully check that the strap is tight at the buckle. Repeat this procedure for the other side.

Adjusting the dioptre

Before you begin taking pictures, ensure that the display on the viewfinder is in clear focus. The Nikon D40 & D40x offer a dioptric adjustment of between −1.7 and +0.5m-1, in order to compensate for minor eyesight defects. To use this facility, slide the dioptre adjustment control up and down until the focus brackets in the viewfinder appear sharp.

Mounting the lens

1) Having first checked that the camera is turned off; remove the rear lens cap and the camera body cap.

2) Align the mounting index on the lens with that on the camera body, position the lens in the bayonet mount and rotate the lens counterclockwise until it clicks into position.

3) If the lens is equipped with an A-M or M/A-M switch, select either A (autofocus) or M/A (autofocus with manual priority).

4) If the lens is designed with an aperture ring, lock the aperture at its minimum setting (highest f-number).

5) To remove a lens, switch the camera off, then depress the lens-release button, and, with the camera facing you, turn the lens clockwise until it stops and you can remove it.

⚠ Common errors

Having removed a lens, replace both
caps immediately. To avoid damage
never touch the electrical contacts
with your fingers and take care to
prevent anything from entering the
camera via the lens mount when
changing lenses. Otherwise, dust will
settle on the CCD sensor, creating
marks on your digital images.

Installing the battery

The Nikon D40 & D40x rely on
rechargeable EN-EL9 Li-ion 7.4V
1000mAh lithium batteries. The
cameras are not compatible with
batteries used in other Nikon
digital SLRs.

1) Ensure the camera is switched off
and then turn the camera upside down
to locate the battery chamber cover.

2) Open the chamber by sliding the
cover latch and lifting.

3) Ensuring that the battery contacts
are facing downwards, insert the pack
until it is in position.

4) Shut the battery chamber cover
until you hear it click. Turn the camera
on and check the battery level
indicator in the monitor display.

⚠ Common errors

Using the battery in cold temperatures
may inhibit its performance; keep it
in a warm, dry place, or tuck it into
clothing when you are out in the field.

It is wise to keep a fully charged spare
EN-EL9 battery handy. If the battery
level is getting low, the battery level
indicator in the shooting information
display and viewfinder will blink and
the shutter is disabled. The battery
will need to be charged or replaced.

Should the battery terminals become
dirty, wipe them with a clean, dry
cloth before use.

Recharging the battery

The MH-23 quick charger, supplied with the camera, must only be used in conjunction with the EN-EL9 battery pack. To recharge the battery, connect the power cord to the charger and plug it into a power outlet. Remove the protective battery cover and slide the battery, with its terminals facing forward and downward, fully into the charger until it gently locks into position. The battery will begin to charge immediately. The charge lamp will blink throughout charging. Charging is complete when the lamp stops blinking, remaining lit. A fully exhausted battery will take approximately 90 minutes to completely recharge. Once the battery pack has been recharged, detach it and unplug the power cord from the power source.

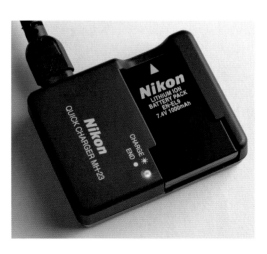

⚠ Warning

The Nikon D40 & D40x should only be used in conjunction with the Nikon brand electrical accessories specified in its instruction manual – bearing the official Nikon holographic seal. You should never use homemade or modified batteries, or try using different types of battery. The use of non-Nikon electrical accessories could damage the camera and invalidate your Nikon warranty.

Never short-circuit, disassemble, modify, or apply heat of any kind to the battery pack or the camera itself. Do not expose batteries to fire, water or physical shock. This could result in igniting, rupturing or leakage.

If excessive heat or smoke and fumes appear during the recharging of your equipment, unplug the charger from the power outlet immediately. If the battery changes colour, appears deformed, or begins to emit smoke or fumes, remove it immediately.

Keep your photographic equipment out of the reach of children and pets. The chemicals in the battery can harm stomach and intestines if they are swallowed, and burn skin.

Basic camera functions

The Nikon D40 & D40x boast the user friendly layout and functions that have made the Nikon D series so popular among both amateurs and professionals alike. Whilst the D40 or D40x can be employed as a point-and-shoot tool, each is a sophisticated and powerful model, capable of delivering high-quality images. Therefore, it would be wasteful to overlook the features that offer you creative control. This section begins with the basic controls.

Note
The first time you switch the camera on, you will be prompted to set language, time and date in the camera's monitor. To do this, follow the steps outlined for World time and Language (pages 94 and 95), under the setup menu. No photographs can be taken until the camera's clock has been set.

Switching the camera on

To turn the Nikon D40 or D40x on, swivel the power switch (circling the shutter-release button) from the off position to on. The camera cannot operate when the power switch is turned off. When you are not using the camera, always keep the power switch turned off to conserve battery life and prevent the shutter-release button being depressed accidentally.

Operating the shutter

The shutter-release button is activated in two stages. Pressing it halfway activates autofocusing and automatic exposure (the shutter speed and aperture). The monitor will also turn off. Smoothly pressing the button down fully will take the photograph – the access lamp will briefly light. Regardless of the state the camera is in (Image Playback, Menu Operation, Image Recording, in fact anything except printing photographs direct), you can return to shooting by pressing the shutter-release button halfway.

Inserting and removing a memory card

The D40 & D40x employ SD (Secure Digital) memory cards for storing images. These are available separately and not supplied with the camera.

1) Turn the camera off. With the camera facing forward, gently slide the card door towards you to open. Slide the card into the slot. Insert it terminals first and with the label facing the back of the camera. Gently push the card fully into the slot until it clicks into place; forcing it may damage both camera and card. The green memory card access lamp will light briefly.

2) Close the card door and turn the camera on. The number of remaining shots will be shown in the LCD monitor and viewfinder. This will depend on the capacity of the card and the file type and quality.

3) To remove the card, first check that the access lamp is off and then switch the camera off. Slide open the card slot cover and press the card to partially eject. The card can now be removed by hand and the cover closed again.

Camera shake

If the camera moves during exposure, the resulting image may appear blurred – a problem known as camera shake. To prevent this, you should use a tripod for longer exposures, or maintain a faster shutter speed for handheld shots. However, in some circumstances, you can increase stability (therefore reducing the likelihood of shake) simply through posture and stance. Grasp the camera grip with one hand and press both of your elbows tight against your body. Support the lens from underneath with your other hand and position your legs so one is slightly ahead of the other. Press the camera lightly against your face and gently squeeze the shutter-release button. Various supports are available: try using a tripod, monopod or beanbag. Or simply try bracing yourself against a solid object such as a wall.

The command dial

The D40 & D40x are designed with a command dial, which can be used in isolation or in conjunction with other buttons to select and set a variety of camera modes and functions. The command dial is one of the camera's most important and regularly used operations, so it is important that you are familiar with its range of uses. Changes to the affected setting are visible in the viewfinder and shooting information display.

Exposure

1) In Programmed auto (P) mode, rotate the command dial to alter the combination of aperture and shutter speed (flexible program).

2) In Shutter-priority auto (S) and Manual (M) modes, rotate the command dial to select a shutter speed.

3) In Aperture-priority auto (A) mode, rotate the command dial to select the aperture.

4) In Manual (M) mode, press the aperture button and simultaneously rotate the command dial to select the aperture.

5) In Programmed auto (P), Shutter-priority auto (S) and Aperture-priority (A) modes, press the exposure compensation button whilst rotating the command dial to set the level of exposure compensation.

Flash

1) Press the flash mode button and simultaneously rotate the command dial to select a flash mode (P, S, A, M, Auto, Portrait, Child, Close-up and Night Portrait modes only).

2) Press the flash compensation and exposure compensation buttons together whilst rotating the command dial to set flash compensation (P, S, A and M modes only).

Fn button

The function that the Fn button performs can be customized to suit the individual from the custom setting menu. This is designed for convenience; allowing quick, easy access to regularly used commands. Once a function is selected via CS 11, press the Fn button and rotate the command dial to make your selection.

Self-timer (default setting)
Press the Fn button whilst rotating the command dial to select self-timer mode (page 51).

Shooting mode
Press the Fn button whilst rotating the command dial to select shooting mode (page 50).

Image quality and size
Press the Fn button whilst rotating the command dial to select image quality and size (pages 75–78).

ISO sensitivity
Press the Fn button whilst rotating the command dial to select ISO sensitivity (page 82).

White balance
Press the Fn button whilst rotating the command dial to select white balance (P, S, A and M modes only). See page 79.

Note
In settings other than self-timer mode, the shooting information display will show an **Fn** icon to the left of the setting that can be altered by pressing the **Fn** button and rotating the command dial.

The shooting information display

At the hub of the D40 & D40x's controls is the unique shooting information display. Whilst many digital SLR cameras rely on displaying camera settings in a small LCD control panel on the top of the camera, the D40 & D40x utilize a graphic display in the camera's large LCD monitor. This provides a general overview of the camera settings, making it simpler to view and also alter its controls. In its default setting of Graphic, aperture and shutter speed (the segmented line surrounding the aperture) are represented graphically. Alternatively, you can select Classic for the info display format (page 92), which displays settings in a format resembling a standard control panel. The shooting information display is an innovative idea, which is not only user-friendly, but also makes the camera more fun to use. Settings displayed are: Image quality; Image size; White balance; ISO sensitivity; Shooting mode; Focus mode; AF-area mode; Metering mode; Flash compensation value; Exposure compensation value and Flash sync mode.

To activate the shooting information display screen, press the **info** button or **i** button (shooting mode only), the **Fn** button, **✦** button or **☒** button (P, S and A modes only). Shooting information will also be displayed immediately after you turn the camera on.

To alter one or more of these settings, press the **i** button whilst the shooting information screen is displayed.

Changing camera settings

1) Depress the **i** button whilst the shooting information screen is displayed.

2) Using the multi-selector, scroll until the setting you wish to alter is highlighted.

2) Press OK to display options for the highlighted setting. Using the multi-selector, scroll to highlight desired option. Press OK to apply setting.

> **Tips**
> The display format will depend on the option selected for info display format in the setup menu (page 92).
>
> Camera settings can also be altered via the shooting or custom setting menus.

KESTREL
The D40 & D40x boast a variety of different program modes, designed to help optimize settings depending on the subject you are photographing.

The mode dial

Located on the top of the camera, next to the pentaprism, is the mode dial. This offers a varied choice of 12 exposure modes, designed to suit different shooting situations and levels of expertise. Which mode you select will depend on how much control you wish to maintain over aperture and shutter speed selection.

The D40 & D40x provide four traditional exposure modes: Programmed auto (P); Shutter-priority auto (S); Aperture-priority auto (A) and Manual (M), which offers full creative control over camera settings. In addition to the 'Point-and-shoot' Auto mode, the camera boasts a choice of seven Digital Vari-Program modes: Auto (flash off); Portrait; Landscape; Child; Sports; Close-up and Night portrait. These are designed to optimize camera settings to suit the selected scene or subject.

Using Vari-programs

1) To select a Vari-program mode, rotate the mode dial until the desired icon is aligned with the white marker. The corresponding Vari-program icon will be displayed in the top left corner of the shooting information display screen.

2) Point the camera at the subject.

3) Semi-depress the shutter-release button halfway to focus. The focus indicator and selected focus point(s) will be illuminated in the viewfinder, as will the shutter speed and aperture settings.

4) Keeping the shutter-release button semi-depressed, compose the picture and fully depress the shutter-release button to take the image.

Auto (flash off)

Exposure settings	The camera selects the best combination of lens aperture/shutter speed without triggering the flash.
Focus area	The camera automatically selects the focus area containing the closest subject.
Use	For general snapshots, but in situations where flash is prohibited or to capture natural lighting under low light.

Portrait

Exposure settings	The camera selects the best combination of lens aperture/shutter speed. If the subject is far from the background or a telephoto lens is used, settings will intentionally soften and blur background detail.
Focus area	The camera automatically selects the focus area containing the closest subject.
Use	For shooting outdoor portraits or indoors under strong lighting. For best results, use a short telephoto lens (70–100mm). If the subject is lit by overhead sunlight, utilize fill-in flash to relieve shadows underneath eyes and nose.

Landscape

Exposure settings	The camera prioritizes the best combination of lens aperture/shutter speed for enhanced depth of field, maximizing back-to-front sharpness.
Focus area	The camera automatically selects the focus area containing the closest subject.
Use	For general scenic photography in good lighting. For best results, use a wideangle lens (18–28mm) and support the camera using a tripod. Note; the built-in flash and AF-assist illuminator are disabled.

Child

Exposure settings	The camera prioritizes the best combination of lens aperture/shutter speed to vividly render clothing and background details; skin tones are recorded soft and natural.
Focus area	The camera automatically selects the focus area containing the closest subject.
Use	Similar to the Portrait Vari-program mode. Use when photographing children playing or for child portraits.

Sports

Exposure settings
The camera prioritizes the best combination of lens aperture/shutter speed to freeze movement. A fast shutter speed is employed to capture dynamic sports shots in which the main subject stands out.

Focus area
The camera focuses continuously while the shutter-release button is semi-depressed, tracking the subject in the centre focus area. If the subject leaves the centre focus area, the camera will continue to focus based on information from the other focus areas.

Use
When photographing any moving subject, for example, sports, moving vehicles, pets, children running and wildlife. Note: the built-in flash and AF-assist illuminator are disabled.

Close-up

Exposure settings
The camera prioritizes the best combination of lens aperture/shutter speed to allow sufficient depth of field for close-up subjects.

Focus area
The camera automatically focuses on the subject in the centre focus area; other focus areas can be selected using the multi-selector.

Use
Use this setting when photographing small objects, like flowers or insects. When possible, use a tripod to prevent camera shake.

Night portrait

Exposure settings
The camera prioritizes the best combination of lens aperture/shutter speed to allow a natural balance between ambient background and artificial subject lighting in portraits taken in poor light.

Focus area
The camera automatically selects the focus area containing the closest subject.

Use
For photographing people in low light. Use a tripod and the camera's self-timer – or the (optional) ML-L3 remote control – to avoid image blur caused by camera shake. Also, turn noise reduction on.

(P) Programmed auto

In programmed auto mode the D40 & D40x automatically set a combination of aperture and shutter speed to achieve the correct exposure in the majority of shooting situations. The camera is in control of the exposure, allowing you to concentrate on composition – ideal for snapshots. Exposure adjustments can be made using flexible program or exposure compensation.

Using programmed auto

1) Rotate the mode dial until **P** is aligned with the white marker. A **P** will appear in the top left corner of the shooting information display.

2) Point the camera at the subject. Semi-depress the shutter-release button halfway to focus. The focus indicator and selected focus point(s) will be illuminated in the viewfinder, as will the shutter speed and aperture settings. Rotate the command dial if you wish to engage 'flexible program'.

3) Keeping the shutter-release button semi-depressed, compose the picture and fully depress the shutter-release button to take the image.

Note
A visual representation of shutter speed and aperture is provided in the monitor by pressing the **i** or **info** button (when Graphic is selected for info display see page 92). The shutter speed and aperture displays will alter if exposure settings are changed.

Flexible program

In programmed auto mode you can vary the exposure combination by rotating the command dial and engaging 'flexible program'. This maintains the overall correct exposure value, but allows you to change shutter speed or aperture.

Rotate the command dial to the right to set a wide aperture (small f-number), to reduce depth of field or create a faster shutter speed to 'freeze' movement. Alternatively, rotate the command dial to the left to select a smaller aperture (large f-number), increasing depth of field or producing a slow shutter speed to blur motion. Whilst each of these combinations produces the same exposure, the results can appear very different visually.

When flexible program is engaged **P*** will appear in the viewfinder. The original settings can be quickly restored by rotating the command dial until the asterisk is no longer displayed.

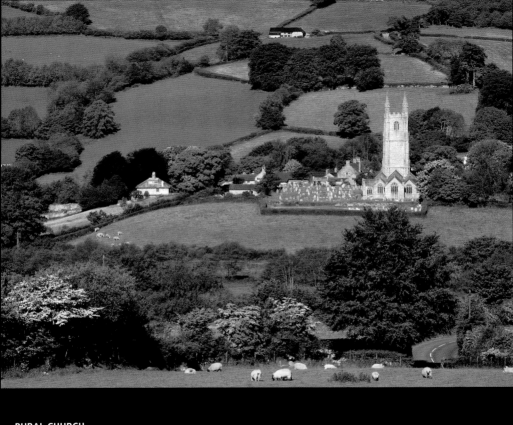

RURAL CHURCH
Whilst Programmed auto (P) mode is
well suited to capturing snapshots and
situations where you solely wish to

MARSH FRITILLARY BUTTERFLY
In this instance, I required a narrow depth
of field to throw the distracting background
vegetation out of focus. Using aperture-priority

(A) Aperture-priority auto

When aperture-priority auto mode is selected, you set the aperture from values between the minimum and maximum for the lens and the camera adjusts the corresponding shutter speed depending on the meter reading. The size of the aperture dictates the depth of field available; the narrower the aperture (the higher the f-number) the more depth of field and vice versa.

By manually selecting the f-number, you can prioritize a small aperture (high f-number), which is useful in situations where you want foreground-to-background sharpness, such as landscape photography. Alternatively, you may wish to select a wide aperture (small f-number), which is useful for shallow depth of field and selective focusing, such as macro work.

Using aperture-priority mode

1) Rotate the mode dial until **A** is aligned with the white marker. The **A** will be displayed in the top left corner of the shooting information display.

2) Point the camera at the subject.

3) Semi-depress the shutter-release button halfway to focus. The focus indicator and selected focus point(s) will be illuminated in the viewfinder, as will the shutter speed and aperture settings. Rotate the command dial to alter the aperture setting. The shutter speed will be automatically altered by the camera to maintain the correct exposure value.

4) Keeping the shutter-release button semi-depressed, frame the picture and fully depress the shutter-release button to take the image.

Tips
Despite its name, aperture-priority auto mode is also a quick, effective method to set the fastest or slowest shutter speeds. To select the fastest shutter speed, set the aperture to its widest value (lowest f-number); to select the slowest shutter speed, set the narrowest aperture available (highest f-number).

The range of apertures available is determined not by the camera, but the lens itself. This will vary depending on the speed of the lens, which is determined by its maximum aperture (smallest f-number).

(S) Shutter-priority auto

Shutter-priority auto mode allows the photographer to select the shutter speed desired while the camera sets the appropriate aperture to maintain an overall correct exposure. Shutter speeds can be set to values ranging from 30sec to 1/4000sec. Being able to control the shutter speed manually in this way is useful for determining the appearance of motion in a scene. For example, if you wish to blur movement then select a slow shutter speed; if you wish to freeze rapid action, set a fast shutter speed. Naturally, the effect achieved will also depend on the speed of the subject and a fast moving subject, like a car or bird in flight, will require a quicker shutter speed in order to freeze it.

Using shutter-priority mode

1) Rotate the mode dial until **S** is aligned with the white marker. The **S** will be displayed in the top left corner of the shooting information display.

2) Point the camera at the subject. Semi-depress the shutter-release button halfway to focus. The focus indicator and selected focus point(s) will be illuminated in the viewfinder, as will the shutter speed and aperture settings. Rotate the command dial to alter the shutter speed. The camera will alter the corresponding aperture value to maintain the overall correct exposure value.

3) Keeping the shutter-release button semi-depressed, compose the picture and fully depress the shutter-release button to take the image. If the camera is unable to produce a corresponding correct exposure at the shutter speed selected, then the electronic analog exposure display – in the viewfinder and shooting information display – will indicate the amount of under- or overexposure. Also, one of the following indicators will be displayed in the aperture display: **HI** = subject too bright; **LO** = subject too dark. In the shooting information display, a warning message will appear with either 'Subject is too dark' or 'Subject is too light.'

> **Tips**
> If you intend using fast shutter speeds to freeze rapid movement, employ a higher ISO sensitivity and/or a lens with a wide maximum aperture.

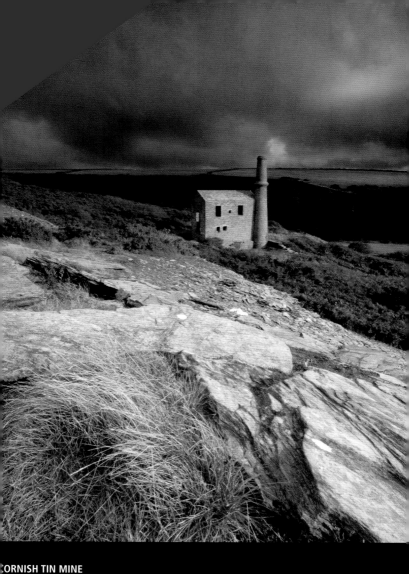

CORNISH TIN MINE
When faced with challenging lighting conditions such
as these, it is important to use your own discretion over
exposure settings rather than rely on the camera's
recommended metering

(M) Manual mode

The most flexible exposure mode available is (M) manual. However, it is also the one that relies most heavily on the photographer's input. Shutter speeds can be set to values ranging from 30sec to 1/4000sec, or infinitely longer using the camera's 'bulb' setting. The aperture can be set between the minimum and maximum value of the lens attached. The camera takes a light meter reading from the scene or subject when you press the shutter-release button halfway, but it doesn't apply the values taken to the exposure settings. Information is displayed in the electronic analog exposure and shooting information displays, but implementation is left to the photographer.

Using manual mode

1) To use (M) manual mode, rotate the mode dial until **M** is aligned with the white marker. An **M** will be displayed in the top left corner of the shooting information display.

2) Point the camera at the subject. Semi-depress the shutter-release button halfway to focus. The focus indicator and selected focus point(s) will be illuminated in the viewfinder, as will the shutter speed and aperture settings. Rotate the command dial to select the shutter speed. To set a corresponding aperture, press the aperture button whilst rotating the command dial. Check exposure value in the electronic analog exposure displays. Adjust until the combination will achieve a correct exposure.

3) Keeping the shutter-release button semi-depressed, frame the picture and fully depress the shutter-release button to take the image.

Electronic analog exposure

At shutter speeds other than bulb, the electronic analog exposure displays, in the viewfinder and shooting information display, whether the photograph would be under- or overexposed at the current settings. By using the command dial – and command dial in conjunction with the aperture button – to adjust the shutter speed, aperture or both, align the indicator with the 0, positioned centrally between –/+ indicators. This will select the exposure value recommended by the camera's light meter. Whilst the sophisticated Nikon metering is rarely fooled, no system is perfect in every lighting situation. Very bright, dark or contrasty conditions may mean that you will have to make fine adjustments to the recommended settings, or indeed to expose creatively. These are two reasons why many photographers prefer the flexibility and control of shooting in manual mode.

Long-time exposures

For lengthy exposures beyond 30sec, the D40 & D40x have a bulb function in which the shutter remains open so long as the shutter-release button is depressed. This facility is useful when shooting in low light or at night. To achieve the correct exposure, you may need to employ a trial and error technique.

To set 'bulb' mode

1) Point the camera at the subject, compose the image and focus.

2) To operate the bulb mode, set the exposure mode to (M) manual. Rotate the command dial until the symbol 'bulb' appears in the electronic analog exposure display, in the viewfinder and shooting information display.

3) Fully depress the shutter-release button. Whilst it is depressed, the shutter will remain open.

⚠ Common errors

To avoid shake when operating the camera in bulb mode, it is essential to mount the camera on a tripod. It is also advisable to operate the shutter via the ML-L3 remote control (available separately) and cover the eyepiece with the DK-5 eyepiece cap to prevent stray light interfering with the metering system.

Selecting the metering mode

Nikon is renowned for the accuracy of its metering system. The D40 & D40x combine data on scene brightness, contrast, colour and, when coupled with a G- or D-type lens, distance-to-subject information in order to calculate an accurate exposure. Each camera is designed with three metering modes: 3D colour matrix II, centre-weighted and spot. When a digital Vari-program is selected, matrix metering is employed by default. However, in exposure modes P, S, A and M, the photographer can determine which part of the scene the camera should use to calculate the exposure of your photograph, through their choice of metering modes. Your decision can potentially make or break the image, so think carefully about which system is the most appropriate for your subject and the shooting conditions you are facing.

The metering mode can be selected via the shooting information display or CS 05 in the custom setting menu.

Tips
To reduce the level of noise, typically created during long exposures, turn on the noise reduction option in the shooting menu (page 83).

3D colour matrix metering

The camera's 420-segment RGB sensor sets the exposure based on a variety of information from all areas of the frame. When a Nikon G- or D-type lens is attached, the camera employs 3D colour matrix metering II, setting exposure according to distribution of brightness, colour, distance and composition for the most natural-looking results – even if the frame is dominated by bright or darks colours. With other CPU lenses, 3D range information is not recorded; instead the camera will employ colour matrix metering II.

Matrix metering is recommended and reliable in the majority of shooting situations, whatever the complexity.

Centre-weighted metering

This is the traditional form of auto-exposure metering. The camera meters from the entire frame, but assigns the greatest weight to the area in the centre of the frame. The D40 & D40x employ a weight of 75% to an 8mm (0.31in) diameter reference circle in the viewfinder.

Typically, centre-weighted metering is utilized in portraiture or in other shooting situations where the subject is prominent, filling the centre of the frame.

Tips
Type G and D AF-S and AF-1 CPU lenses are recommended with the D40 & D40x, supporting the sophistication of 3D colour matrix metering II. Automatic metering is only available with CPU lenses.

Spot metering

Spot metering is the most precise system available to users of the Nikon D40 & D40x. To calculate the overall exposure, it employs a reading from a circle, 3.5mm (0.14in) in diameter, covering approximately 2.5% of the frame. In Dynamic-area and Single-area AF-area modes, the circle is centred on the current focus area selected, making it possible to spot meter from off-centre subjects. If Closest subject AF-area mode is selected, the camera will obtain its spot meter reading from the centre focus area.

This system is ideal for ensuring that the main subject is correctly exposed, even in situations where the background is much brighter or darker. An example of this is when a subject is backlit.

Autoexposure lock

When using centre-weighted or spot metering modes, if the subject is not in the metering area the camera will base its exposure on background lighting conditions. As a result, the main subject may not be correctly exposed. This can be prevented by using the autoexposure lock.

1) Using the mode dial, select P, S or A exposure mode and choose centre-weighted or spot metering.

2) Compose your image with the subject positioned in the selected focus area. Press the shutter-release button halfway and confirm that the in-focus indicator appears in the viewfinder. Keeping the shutter-release button semi-depressed, press the AE-L/AF-L button to lock the exposure.

3) While exposure lock is activated, an EL indicator appears in the viewfinder. Keeping the AE-L/AF-L button pressed, recompose your shot. Finally, fully depress the shutter-release button to take the photograph.

Note
Exposure lock has no effect when the camera is in (M) manual mode.

When exposure lock is in effect, the command dial can still be used to adjust exposure settings in the same way you would normally in P, S and A modes, respectively.

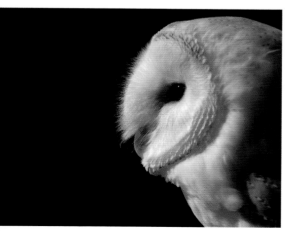

BARN OWL
Autoexposure lock is a vital tool in situations where the subject is not in the metering area – when using centre-weighted or spot metering. If I hadn't used autoexposure lock when I photographed this owl, the camera would have based its meter reading from the black background and the resulting image would have been grossly overexposed.

Exposure compensation

Although the Nikon D40 & D40x boast an accurate, sophisticated exposure system, it is not infallible. Because metering systems are based around the assumption that the subject being photographed is mid-tone, it can incorrectly expose subjects that are considerably lighter or darker. Subjects that are darker than mid-tone can often be recorded overexposed, as the meter takes a reading that will render them mid-tone. Conversely, very light subjects can fool the camera into underexposing them, making them appear darker than reality. Fortunately, with a little experience, the errors that are likely to occur are predictable and photographers can compensate accordingly.

For example, if a subject is significantly lighter than mid-tone it is likely to be underexposed by the camera's meter, so apply positive exposure compensation. The exact level of positive or negative exposure compensation required will depend on the subject and the lighting. It can sometimes prove tricky to judge, so if you are in a situation where compensation is needed, it may be worthwhile bracketing your exposure settings. This is term used to describe taking multiple photographs of the same scene, just using different exposure settings. Begin by taking a frame using the camera's recommended settings and then shoot subsequent photographs applying both negative and positive exposure compensation – in small increments. This approach should guarantee that one frame will be perfectly exposed and the poorly exposed frames can then be deleted (page 64).

Tips
The nature of digital sensors means they tend to be more prone to overexposure than underexposure. Therefore, unless you are shooting in controlled, average conditions, it can be worth shooting with –1/3 or –2/3 exposure compensation applied at all times to help prevent highlights from 'burning out'.

⚠ Common errors
Remember to reset exposure compensation when you have finished shooting a particular subject or scene. Otherwise you will apply exactly the same level of compensation to the next subject you photograph; running the risk of shooting incorrectly exposed images.

Using exposure compensation

Exposure compensation is only available in P, S, A and M modes and can be set between −5Ev and +5Ev in increments of 1/3Ev. It is most effective when used in combination with centre-weighted or spot metering. There are two ways of setting exposure compensation.

1) Press the ⚡ button and rotate the command dial to set the exposure compensation value you require, displayed in the shooting information display and viewfinder (P, S and A modes only).

2) Alternatively, with the shooting information screen displayed, depress the ℹ button to adjust the camera settings. Using the multi-selector, scroll to Exposure Comp. and press OK. Scroll up or down to set the compensation value – the displayed image to the left

of the setting will lighten or darken to represent the effect of the parameter. Press OK to apply.

3) Once exposure compensation has been applied, a ⚡ will be displayed in the viewfinder to indicate a positive or negative compensation has been programmed. Also, the 0 at the centre of the electronic analog exposure display in the viewfinder will flash. The current value for exposure compensation is shown in the shooting information display.

4) Frame the image, focus and depress the shutter-release button to take the picture. To restore normal exposure settings, set compensation value to +/−0; the ⚡ symbol will disappear from the viewfinder.

EXP.COMP. (0EV)
The bright sunlight reflecting from this cottage's white walls has caused the camera to underexpose the image overall.

EXP.COMP. (+1EV)
Positive compensation of one stop has corrected the problem, and the image is correctly exposed.

Flash exposure compensation

The Nikon D40 & D40x allow you to alter the power of the flash emitted by either the built-in unit or of an additional Nikon Speedlight. Flash exposure compensation is only available in P, S, A and M modes and should be applied to increase or reduce flash output from the level set by the camera. Applying positive compensation will increase the illumination from the flash unit and is often most useful when the main subject is darker than its background. Negative compensation will reduce the power of the burst and is best suited to shooting situations where the main subject is lighter than its surroundings.

The D40 & D40x can be used to alter flash output by −3Ev to +1Ev in increments of 1/3Ev. For more information see page 149 in Chapter 4.

Tips
If the range of brightness within a static scene falls outside of the dynamic range of the camera, then mount the camera on a tripod and take a bracketed sequence of shots, one of which should act to retain detail in the highlights, one which should provide a good base exposure and one that retains detail in the shadows. These individual frames can then be combined during post-processing – using photo editing software like Photoshop – to create a correctly exposed image overall.

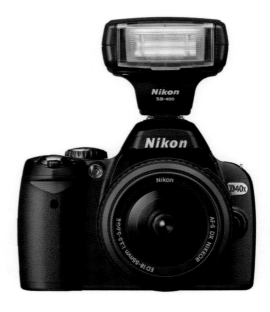

USING FLASH
The Nikon D40x with the SB-400 speedlight flash mounted. Even with a basic flash unit, you can exert a great deal of control over your images using flash exposure compensation.

Selecting a shooting mode

There are five shooting mode options: single frame (default); continuous; self-timer; delayed remote and quick-response remote.

1) With the shooting information displayed on the monitor, depress the **i** button to adjust camera settings.

2) Using the multi-selector, scroll to shooting mode and press **OK**. Scroll up or down to set the compensation value. The displayed image to the left of the setting represents the role of that particular parameter. Press **OK** to apply.

MAPLE LEAF
It was a windy day when I photographed this colourful leaf. To ensure I took at least one frame where it was correctly composed, I employed the camera's continuous burst shooting mode and shot a sequence. The frames where the leaf was in the wrong position due to the wind, I simply deleted.

> **Note**
> The shooting mode can also be selected via CS 04 in the custom setting menu (page 86).

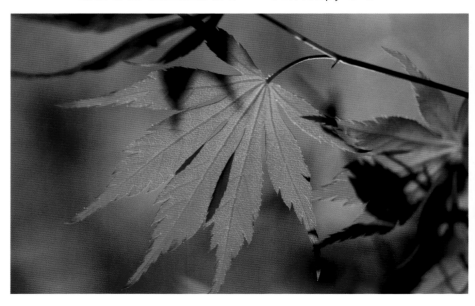

Shooting mode options

Setting	Description
Single frame (default)	The camera will take a single frame each time the shutter-release button is depressed. Suited to scenic photography and everyday picture taking situations.
Continuous (burst mode)	While the shutter-release button is held down, the camera shoots at up to 2.5fps (D40) or 3fps (D40x), depending on the shutter speed. This burst rate is reduced if noise reduction (NR) is switched on. Photographs taken at HI 1 (ISO 3200 equiv.) are automatically processed to reduce noise, increasing recording time by approximately one second per frame. Only one frame will be taken if the flash fires.
Self-timer	Delays shutter release by 10sec. Use the self-timer for self-portraits or to minimize camera movement caused by pressing the shutter-release button. Use the setting in conjunction with a tripod or place the camera on a stable, level surface. If the self-timer is selected for CS 11, self-timer mode can also be selected by pressing the self-timer button.
Delayed remote	Shutter is released by the (optional) ML-L3 remote control unit. The D40 & D40x will focus (in AF mode) when the shutter-release button on the ML-L3 is pressed and the shutter is released two seconds later. Use for self-portraits or to minimize camera movement caused by pressing the shutter-release button. Use the setting in conjunction with a tripod or place the camera on a stable, level surface.
Quick-response remote	Shutter is activated by the (optional) ML-L3 remote control unit. The D40 & D40x will focus (in AF mode) when the shutter-release button on the ML-L3 is pressed and exposure occurs immediately after. Ideally suited to prevent blurring caused by camera shake. Use the setting in conjunction with a tripod or place the camera on a stable, level surface.

Max frames per single continuous burst
Image quality setting
JPEG Fine/Normal/basic (Large/medium/small) = 100
Uncompressed NEF (RAW) = 5
Uncompressed NEF (RAW) + JPEG (basic) = 4

The buffer

When taking pictures, the images are first stored in the camera's internal buffer memory before being transferred to the SD card. While the shutter-release button is pressed, the number of images that can be stored in the memory buffer, at the current settings, is shown in the exposure-count display in the viewfinder. When the buffer is full, the shutter is disabled until sufficient data is transferred to the memory card to make room for further images. In continuous shooting mode, shooting will continue to a maximum of 100 frames as long as the shutter-release button is held down. However, frame-rate will drop once the buffer is full.

⚠ Common errors

The exposure-count displays, in the viewfinder and shooting information display, show the number of frames that can be stored on the inserted SD card at the present settings. Check regularly to see how many exposures remain. When there isn't room to store additional shots at the current settings 'FUL' will flash in the viewfinder and the message 'card is full' will appear on the monitor. No further images can be taken until the memory card has been replaced (page 28) or pictures have been deleted (page 64).

Focus mode

Focus can be quickly switched between autofocus and manual via the shooting information display or CS 02 from the custom setting menu. The D40 & D40x boast three autofocusing modes in addition to manual focusing.

AF-A Auto-servo AF

This is the camera's default setting. The camera automatically selects Single-servo autofocus when the subject is judged to be stationary or Continuous-servo autofocus when the subject is judged to be moving. The shutter can be released if the camera is able to focus.

MF Manual focus

Adjust focus manually, using the lens focusing ring until the clear matte field in the viewfinder is in focus. Photographs can be taken at any time, even when the image is not in focus. Manual focusing is best suited to situations where autofocusing is less appropriate, such as macro photography, for example, or when there are low light levels.

AF-S Single-servo AF

In this focus mode, the D40 & D40x will focus when the shutter-release button is pressed halfway. Focus locks when the focus indicator appears in the viewfinder and remains locked while it remains pressed halfway. This mode is best suited to stationary subjects.

AF-C Continuous-servo AF

In Continuous-servo AF mode, the camera will continue to focus while the shutter-release button is pressed halfway; if the subject moves, focus is adjusted to compensate. The shutter can be released if the camera is able to focus. This focus mode is intended for moving subjects, like animals, birds in flight or moving vehicles.

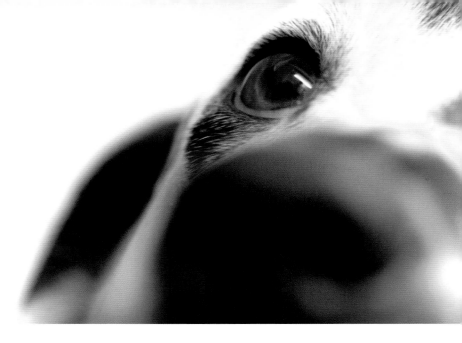

DALMATIAN
AF-C Continuous-servo AF is best
suited to moving subjects, such as
children playing, wildlife or pets.

AF area mode

The three different AF areas determine
how the focus area is selected in
autofocus mode. Select the AF area
mode to suit the subject you are
about to photograph.

1) With the shooting information
displayed on the monitor, depress the
i button to adjust camera settings.
Using the multi-selector, scroll to AF-
area mode and press **OK**. Scroll up or
down to highlight the setting desired.
The displayed image to the left of the
setting represents the role of that
particular parameter. Press **OK**.

Notes
The shooting mode can also be
selected via CS 03 in the custom
setting menu.

This setting has no effect when the
camera is in manual focus mode.

The AF-area mode in use is
indicated in the focus area display
in the viewfinder.

Single-area AF

This mode allows you to designate the focus area and your choice will remain unchanged even if the subject moves. Therefore, this mode is well suited to shooting static subjects, like scenics, still-lifes and portraits.

This mode is selected automatically when the Close-up Vari-program is in use.

Dynamic-area AF

This mode allows you to select a focus area and your choice of primary focus area will remain unchanged by the D40 & D40x. Should the subject move outside the selected focus area, the camera will use the other focus areas to keep it in focus; however, the focus area selected originally will not alter. This mode is best suited for keeping moving and erratic subjects in focus.

This mode is selected automatically when the Sports Vari-program is in use.

Closest subject

The D40 & D40x will automatically select the focus area containing the subject closest to the camera. This helps prevent photographing out-of-focus shots when photographing erratically moving subjects. You cannot select the focus area manually.

This is the default setting for P, S, A and M exposure modes. This mode is selected automatically when the Auto, Auto flash off, Portrait, Landscape, Child and Night portrait Vari-program is in use.

Tips
While the closest subject and dynamic area modes may appear quite similar, they do offer two fundamentally different options. Closest subject allows you to leave the camera to make the decisions and is best employed when you are unsure of the photographic challenges you might face. Dynamic area offers the same core predictive tracking technology and is a better choice if you are able to spend a little time setting up the shot.

Tracking a subject that is moving erratically requires skill, even with the aid of dynamic area AF. Try practising your technique at a local sporting event, or you could visit a wildlife park and practise on captive animals.

Focus areas

Looking through the viewfinder of the Nikon D40 or D40x, you will see the camera's three focus area sensors/brackets. In its default setting, the camera selects the focus area automatically or focuses on subjects in the centre focus area. However, the focus area can also be selected manually. This is designed to enable you to select the focus area sensor that most closely matches the position of the subject you are photographing. This makes autofocusing a far easier task, requiring less camera movement and reframing.

Selecting focus areas

1) At the camera's default settings, the focus area is selected automatically in P, S, A and M exposure modes and Auto, Auto flash off, Portrait, Landscape, Child and Night portrait Vari-programs. Select single-area or dynamic-area AF-area modes to enable manual selection of the focus sensors.

2) Press the multi-selector left or right to select the focus area accordingly. The selected focus area bracket will be highlighted red in the viewfinder and will appear in the relevant position in the viewfinder and shooting information displays.

BACKLIT LEAVES
Being able to select the focus area manually is helpful when photographing off-centre subjects.

Focus lock

Once the camera has achieved focus, you can lock it if you wish to alter composition. This allows you to transfer the point of focus to an area not covered by one of the camera's three focus areas. Use single or dynamic area AF with focus lock.

1) Position the subject in the selected focus area and press the shutter-release button halfway to focus. Focus will lock automatically when the in-focus indicator appears, and remain locked while the shutter-release button is semi-depressed. Focus can also be locked by depressing the $\frac{AE-L}{AF-L}$ button – it remains locked while this button is depressed, even if you move your finger from the shutter-release button.

2) Recompose the image and fully depress the shutter-release button to take the photograph.

Note
In continuous shooting mode, Sports Vari-program and Continuous-servo AF, focus can only be locked with the $\frac{AE-L}{AF-L}$ button. At its default setting, the $\frac{AE-L}{AF-L}$ button will also lock exposure. Vary the role of the $\frac{AE-L}{AF-L}$ button using CS 12 in the custom setting menu.

Tip
Do not alter the distance between the camera and subject while focus lock is in effect. If you or the subject moves during focus lock, remember to focus again at the new distance.

The AF-assist illuminator

When the D40 & D40x focus in low light, the camera employs the AF-assist illuminator to increase subject contrast when the shutter-release button is semi-depressed. For the AF-assist to function properly the lens must have a focal length in the range of 24–200mm and the subject should be within around 1ft 8in–9ft 10in (0.5–3m). Remove the lens hood if there is one attached.

The AF-assist illuminator will not light when the camera is in Continuous-servo AF or manual focus mode, in Landscape or Sports Vari-program.

Note

The AF assist illuminator can grow hot with consecutive use and, if it's been used several times in succession, it may turn off briefly to protect the lamp. The illuminator can be switched off if required, using CS 09 in the custom setting menu.

Tips

If the lens attached has a maximum aperture of f/5.6 or faster, the viewfinder focus indicator can be used to confirm whether the subject in the selected focus area is in focus. First, select one of the focus areas (page 58) and then press the shutter-release button halfway. Focus using the lens-focusing ring and, when the subject closest to the activated focus area is in focus, the green in-focus indicator will be displayed in the viewfinder.

⚠ Common errors

When shooting using manual focus, photographs can be taken at any time, even if the image is out of focus.

Manual focus

There may be times when autofocus isn't effective; in low light, or when shooting low contrast, extremely backlit or reflective subjects. For example, problems can occur when faced with overlapping near and far objects, fine detail or repetitive geometric patterns. Often, this can be resolved by focusing on an object at the same distance as the subject and locking the focus using focus lock (page 57). Alternatively, focus manually.

1) Switch the focus mode to MF, either via the shooting information display or CS 02. If using a lens offering A/M selection, ensure M is selected when focusing manually.

2) Rotate the focusing ring of the attached lens until the subject appears in sharp focus in the viewfinder.

3) Semi-depress the shutter-release button halfway. The focus indicator, in the viewfinder, will be displayed if the subject in the selected focus area is in focus.

Image playback

Single images

In its default setting, the camera displays the most recently taken image on its LCD monitor. The battery level and number of exposures remaining are also displayed. Images can be reviewed at any time by pressing the ▶ button.

To conserve battery life, automatic image review can be switched off via CS07 in the custom setting menu.

Images taken in vertical format can be displayed 'tall' by switching on Rotate tall via the playback menu (page 66).

Viewing additional images

When there is more than one image stored on the inserted memory card, you can scroll through images by using the multi-selector. First, press the ▶ button to view images. Press the multi-selector left to scroll through pictures in reverse order, or right to view images in the order they were captured.

Viewing photo information

Along with the actual image taken, the camera records shooting data. This can be accessed via the monitor by pressing the multi-selector up or down while an image is being replayed.

Photo information

Photo information is superimposed on images displayed in single-image full frame playback. There are up to six pages of information for each photo. Press the multi-selector up and down to cycle through File information, Shooting Data Page 1, Shooting Data Page 2, Retouch History, Highlights and Histogram.

Playback zoom

Images in single-image playback can be magnified using the camera's playback zoom; useful for scrutinizing image sharpness. It is possible to achieve a magnification of 19x (large images), 15x (medium images) or 10x (small images).

1) Press the ⊕ button to zoom in on the image displayed in single-image playback. Each time this is pressed the level of magnification will increase. A navigation window is displayed in the monitor to indicate the area of the image currently visible.

2) Use the multi-selector to move the selected area visible in the monitor to other areas of the frame. Keep the multi-selector depressed to scroll rapidly. To view other images at the chosen zoom, rotate the command dial. Press the ⊖ button to zoom out again.

Viewing thumbnail images

Rather than view photographs as single, full-screen images, pictures can be viewed as four or nine small-sized thumbnails. This can be useful when you wish to review a number of shots, or when comparing one image with another.

1) To select the thumbnail playback option, press the Q▦ button while an image is displayed on the monitor. This will display four thumbnail images. Press the Q▦ button again to display nine thumbnail images.

2) Use the multi-selector or command dial to highlight an individual photograph. Press **OK** to view the selected image full frame. You can also delete or protect selected thumbnail image, by pressing the relevant button.

3) Press the Q button to decrease number of images displayed from nine to four or four to full frame playback.

Note
The monitor will turn off automatically after a period of no operation. The length of time the monitor remains active can be set using CS15 in the custom setting menu.

Histograms

The histogram is a graph showing the brightness distribution of the image (displayed in single-image playback). Learning how to interpret the histogram can improve your images, chiefly by allowing you to assess the exposure of the tonal range, before making any adjustments to improve it.

The horizontal axis of the graph displays the brightness levels, while the vertical one shows the number of pixels. If peaks appear to the left of the histogram, the image is dark; to the right and the image is bright. If there are too many pixels at the extreme left, then shadow detail in the final image will be lost; if there are too many pixels at the extreme right, then highlight detail will be lost. The histograms are intended as a guide only and may differ from those displayed in imaging applications.

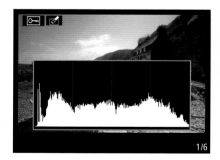

HISTOGRAM
Histograms give valuable information on the level of brightness detected by each pixel.

An image's highlights can be displayed in single-image playback, using the multi-selector to scroll through the photo information pages. Highlights are overexposed areas of the image that contain pixels that are pure white and will appear devoid of detail in the final image. When this shooting information is displayed on the LCD monitor, any highlights in the image will blink. To obtain more detail in the overexposed areas, set negative exposure compensation (page 48), and try again. If you are shooting a particularly light subject the histogram may suggest that large portions of the image are overexposed. In these instances, you must use your own discretion and judgement to assess whether or not this is correct.

HIGHLIGHTS
In this image the highlight detail of the water flowing over the weir has been lost.

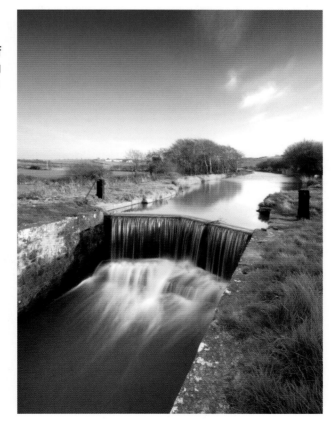

Two-button reset

1) Hold down the **info** and ⊕ buttons, indicated with green dots, together for more than two seconds. The monitor will turn off briefly. The camera settings shown below can be restored to their default values (custom settings are unaffected by the two-button reset).

Option	Default
Image quality	JPEG Normal
Image size	Large
White balance	Auto
WB Fine tuning	0
ISO sensitivity	
Digital Vari-programs	Auto
P, S, A, M modes	200
Shooting mode	Single frame
Focus mode	AF-A
AF-area mode	
Auto, Auto flash off,	
Portrait, Landscape,	
Child, P, S, A, M modes	Closest subject
Sports	Dynamic area
Close-up	Single area
Metering	Matrix
Flash compensation	+/–0
Exposure compensation	+/–0
Flash sync mode	
Auto, Portrait, Child	
Close-up	Auto
Night portrait	Auto slow sync
P, S, A, M modes	Fill-in flash
Focus area	Centre
Flexible program	Off

Using the D40 & D40x menus

Many of the camera's functions are accessed via the menu screens, which are displayed on the LCD monitor. There are five menus from which to choose: playback menu; shooting menu; custom setting menu; setup menu and retouch menu.

SETUP MENU

CSM/Setup menu	
Format memory card	––
Info display format	info
Auto shooting info	
World time	––
LCD brightness	0
Video mode	NTSC

Navigating the menus

The playback menu is underlined in blue and is dedicated to adjusting playback settings and managing photos. The shooting menu is underlined in green and is dedicated to shooting related functions, such as ISO sensitivity, white balance and noise reduction. The custom setting is underlined in red and is dedicated to fine-tuning settings such as metering, autofocus and timers. The setup menu is underlined in orange and can be used to adjust LCD brightness, language and world time. The retouch menu, underlined in purple, is designed to create retouched or enhanced copies of existing images.

Each menu can be easily accessed and adjusted in a simple three-step process – select a menu, then a menu item and finally a menu setting. Unless otherwise stated, all of the operations related to menu choices assume that the power switch is already on.

1) To display the menu screen, press the **MENU** button. Scroll the multi-selector up or down to highlight the desired menu. To select a menu, press **OK** or the multi-selector to the right.

2) Using the multi-selector, scroll through the options and highlight the required setting. To select, press **OK** or the multi-selector to the right.

3) To return to the previous list, press the multi-selector to the left or press the **MENU** button to return to the menu screen. If you wish to exit the menus at any time, then semi-depress the shutter-release button.

Tip
Any discussion of menu selection, items or settings assumes that you have pressed the **MENU** button to display the menu screen.

The playback menu

One of the advantages of digital capture is the ability to review images on the LCD monitor. The D40 & D40x's playback menu controls five different options and can be used to view and manage your pictures in camera. The playback menu is only displayed when a memory card is inserted.

PLAYBACK MENU	
Delete	🗑
Playback folder	NCD40
Rotate tall	ON
Slide show	⏱2s
Print set (DPOF)	⌷

Delete

Any unprotected images captured using the D40 or D40x and stored on the inserted memory card can be deleted easily, either individually or collectively.

Delete
1) To delete one or more images individually, highlight and select Delete from the playback menu.

2) In the menu options screen, highlight and choose Selected. The photographs in the folder or folders selected in the playback folder menu (page 66) will be displayed on the monitor as thumbnail images.

3) Use the multi-selector to navigate through the images. Press the 🔍 button to view the highlighted image full screen – release to return to the thumbnail list. Press the multi-selector up or down to select the highlighted

shot for deletion. The shot will be marked by a 🗑 icon. To deselect an image, highlight it and again press the multi-selector up or down.

4) Repeat the previous steps to select additional images.

5) Press **OK** to display a confirmation screen. Highlight No, to exit without deleting images or Yes, to delete selected images and press **OK**.

Delete all
1) To delete all images, highlight and select Delete from the playback menu.

2) In the menu options screen, highlight and select All. Highlight No, to exit without deleting images or Yes, to delete all images in the selected folder or folders selected in the playback folder menu and press OK.

Delete in playback

Photographs can also be deleted when displayed in single image or zoom playback, or if the photograph is highlighted in four or nine thumbnail playback.

1) Press the ▶ button and display the image for deletion in the camera's monitor or highlight in the thumbnail playback.

2) Press the 🗑 button. A confirmation screen will be displayed. Press the 🗑 button again to erase the image permanently or press the ▶ button to cancel and exit without deleting the photograph.

Note

Pictures that are protected will not be deleted. When using high capacity memory cards, containing a large number of files or folders, deleting all using this method can be a lengthy process. If you wish to delete all data from a memory card, it is quicker and best to format the card (page 92).

Protecting images

One of the few drawbacks of digital capture is that images can be deleted accidentally before they have been safely transferred to a home computer or storage device. Once an image has been erased, it cannot be recovered. To help prevent accidental deletion, it is possible to protect valuable images by pressing the 🔘 button. Protected files cannot be erased using the 🗑 button or delete option in the playback menu and have a DOS 'read only' status when viewed on a Windows computer.

1) Display the image in full frame playback or highlighted in the thumbnail list.

2) Press the 🔘 button. The photograph will now be marked with a 🔘 icon to indicate it is safe from deletion. Even if the 🗑 button is pressed the image will not be erased.

3) To remove protection, display the image in full frame playback or highlighted in thumbnail list. Press the 🔘 button. The 🔘 icon will disappear and the image can be deleted. Note that protected images are not safe from deletion when the card is formatted (page 92).

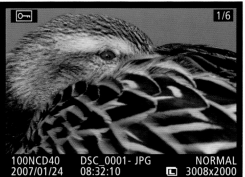

PROTECTED IMAGE
Images that are protected are safe
from accidental deletion.

Tip
To remove protection from all
images currently selected, press
the ▣ and 🗑 buttons together
for around two seconds. You will
then be prompted to press the
🗑 button if you wish to continue
and remove protection.

Playback folder

All images taken are stored in a folder
(or folders). Use the playback folder
menu to display images within the
current folder or all folders.

1) Highlight and select Playback
Folder in the playback menu.

2) From the options menu, select
Current, to allow only images in the
folder currently selected – using the
folders option in the setup menu
(page 96) – to be displayed during
image playback; or All, to allow
images in all folders created by the
camera that conforms to the Design
rule for Camera File system (DCF).

Rotate tall

This menu determines whether
photographs taken in vertical (tall)
orientation are automatically rotated
for display in playback.

1) Highlight and select Rotate tall
from the playback menu. Select
On, to rotate vertical images
automatically, or Off, to display
tall images horizontally.

Slide show

Instead of playing back images one at a time, you can set the Nikon D40 or D40x to replay images in an automated sequence, much like a slide show.

1) Highlight and select Slide show from the playback menu.

2) Highlight and select 2s Frame interval. Highlight the appropriate time interval you would prefer between images being displayed from 2, 3, 5 or 10sec. Press OK or the multi-selector to the right to select and return to the slide show menu.

3) Highlight and select Start to begin slide show. All images in the folder or folders selected in the playback folder menu will be played back in the order they were taken.

Note
When the slide show ends, or when the **OK** button is pressed to pause playback, a dialog box is displayed. Using the multi-selector, highlight and select an option from Restart, Frame Interval or Exit.

The following operations can be performed during a slide show

Press the multi-selector left to return to the previous frame or right to advance to the next frame.

Press the multi-selector up or down to alter photo information displayed during playback.

Press the **OK** button to pause the slide show.

Press the **MENU** button to end the slide show and display the playback menu.

Press the ▶ button to return to the playback menu with the current image displayed on the monitor. Semi-depress the shutter-release button to end the slide show, turn monitor off and return to the shooting mode.

Print set

Photographs can be printed directly to a Digital Print Order Format (DPOF) or PictBridge printer. DPOF is an industry standard; check whether your printer supports it. NEF (RAW) images cannot be selected for direct printing.

1) Highlight and select Print Set from the playback menu. To select the images for printing, choose Select/Set. The photographs in the folder(s) selected in the playback folder menu (page 66) will be displayed on the monitor as thumbnail images.

2) Use the multi-selector to navigate through the images. Press the ⊕ button to view the highlighted image full screen – release to return to thumbnail list. Press the multi-selector up to select an image. Selected images are marked with a ⏄ icon. Each time the multi-selector is pressed up, the number of prints will increase by 1 (up to 99).

3) Repeat step 2 to select additional images. To deselect images, press the multi-selector down when number of prints is 1. The ⏄ icon will no longer be displayed. To exit without changing the print order, press the **MENU** button. To confirm the print order, press the **OK** button. A sub-menu will be displayed. Highlight and select Data Imprint, to print the shutter speed and aperture on all the pictures

in the print order; Imprint Date to print the data the picture was taken on all images in the print order; or Done to complete print order modification.

5) To remove all images from the print order, highlight and select Print Set from the playback menu. Choose Deselect All? A confirmation dialog box will be displayed. Highlight and select No, to return to the playback menu without altering the print order, or Yes, to remove all images from the print order. The message 'Markings removed from all images' will be displayed.

Tips

The Print Set (DPOF) option cannot be accessed if there is not enough space on the memory card. Print orders may not print correctly if images are deleted on a computer after the print order has been created. When taking pictures to be printed without modification, set the colour mode (page 73) to Ia (sRGB) or IIIa (sRGB).

The D40 & D40x support Exif (Exchangeable Image file Forma for digital still cameras) version 2.21, which allows information stored with photographs to be used for optimal colour reproduction when output on Exif-compliant printers.

The shooting menu

The camera's shooting menu controls shooting related functions, including image quality, size, white balance and noise reduction. Although these parameters may make using a digital camera seem more daunting at first, ultimately they provide you with greater flexibility than when using film. The majority of the functions found under the shooting menu can also be adjusted via the shooting information display.

▶	SHOOTING MENU	
📷	Optimize image	⃠N
✎	Image quality	NORM
	Image size	▣
🍴	White balance	AUTO
🔧	ISO sensitivity	200
	Noise reduction	OFF
❓		

Optimize image

Unlike film photography, where all image processing takes place outside the camera, the Nikon D40 & D40x enable some in-camera processing. There are six pre-defined settings via Optimize Image in the shooting menu, intended to suit different shooting scenarios. There is also a Custom option, where you can optimize sharpening, tone, colour mode, saturation and hue to suit the shooting conditions. The optimize image option is only available in P, S, A and M modes.

Highlight and select optimize image from the shooting menu and choose from the options shown on page 70.

EARLY-PURPLE ORCHIDS
An Optimize image setting of Vivid is well suited to photographing flora and fauna, saturating and enriching colours.

Option	Effect
Normal	Normal processing is applied to all images and is recommended in most situations.
Softer	Designed to soften outlines, producing natural-looking results. Best suited for portraits or retouching on a computer.
Vivid	Enhances saturation, contrast and sharpness to produce crisp, vibrant images and well-defined detail.
More vivid	Designed to maximize saturation, contrast and sharpness to create crisp, vivid images with sharp outlines and well-defined detail.
Portrait	Contrast is reduced and background detail softened. Skin tones have a smooth, flattering natural look.
Black and white	Records images in black and white.
Custom	Allows the photographer to customize settings.

Notes

In settings other than Custom, a colour space of sRGB is employed.

The results are optimized for the current shooting conditions and will vary depending on the exposure and position of the subject in the frame. If you require consistent results over a series of images, it is best to opt for Custom and select a setting other than Auto for image sharpening, tone compensation and saturation.

Manually adjusting image optimization: sharpening

Image sharpening controls the appearance of borders between light and dark areas of the photo. Be wary when applying in-camera sharpening. The results might look seductive on the monitor, but over-sharpening can potentially ruin a good image and is much harder to correct during post-processing than under-sharpening.

1) From the shooting menu, select Optimize Image and, using the multi-selector, highlight and select Custom. A custom menu will appear.

2) Select Image Sharpening and, using the table below, enter the level of sharpening to be applied. Press **OK** to select.

Image sharpening	Effect
A Auto (default)	The D40 & D40x automatically set the level of sharpening depending on the scene.
◇ 0 Normal	Images are sharpened by the standard amount needed in most situations and conditions.
◇ −2 Low	Sharpening is reduced from the standard level. Used when soft edges are required.
◇ −1 Medium low	Sharpening is only slightly reduced from the standard amount, giving slightly softer edges.
◇ +1 Medium high	Sharpening is slightly increased from the standard level, giving subjects a marginally harder edge.
◇ +2 High	Sharpening is greatly increased from the standard amount, giving subjects a well-defined edge.
◇ None	No sharpening is applied.

Manually adjusting image optimization: tone compensation

This controls contrast by adjusting the distribution of tones in the picture using tone curves. This is a useful menu for images that will need to be used as they are recorded.

1) From the shooting menu, select Optimize Image and, using the multi-selector, highlight and select Custom. A custom menu will appear.

2) Select Tone Compensation and, using the table below, enter the level of compensation required. Press **OK** to select.

Tone compensation	Effect
A Auto (default)	The D40 & D40x automatically set the contrast curve depending on the scene.
◑ 0 Normal	The camera employs a standard curve for all images, suitable for most picture-taking situations.
◑ – Less contrast	The image is softened to help prevent highlights being rendered without detail in direct sunlight. Particularly well suited to portraits.
◑ + More contrast	The camera sets a curve that increases the level of contrast. Can be used to retain detail in hazy and misty conditions.
◑✎ Custom	Allows you to define a custom curve in optional Nikon Capture NX software and download it to the D40 or D40x.

Manually adjusting image optimization: colour mode

Similar to the way in which different types of film suit different subjects, the D40 & D40x offer a choice of colour modes with subtly different palettes, which can be selected at your discretion.

1) From the shooting menu, select Optimize Image and, using the multi-selector, highlight and select Custom. A custom menu will appear.

2) Select Colour Mode and choose from Ia: images are in the sRGB colour space with colours optimized to produce natural-looking skin tones; II: images are in the Adobe RGB colour space, supporting a wider gamut of colours and best suited for further processing; or IIIa (default setting): images are in the sRGB colour space, but are more vivid, suited to nature or scenic photography.

Colour mode	Effects
I	Images are adapted to the sRGB colour space with colours matched to produce natural-looking skin tones without further computer modification. Best used when photographing portraits.
II	The setting matches the colour space with the Adobe colour space that has a wider gamut of colours than sRGB. Select for images that will be extensively processed or retouched. Only available when AdobeRGB is selected in colour space.
III	Colours are matched to produce vivid nature and landscape images.

Saturation	Effects
A Auto (default)	The D40 & D40x automatically adjust the saturation according to the subject. Best results are achieved using type G or D lenses.
0 Normal	The D40 & D40x will record natural-looking vividness.
– Moderate	Reduces colour saturation. Best employed only when images will be heavily enhanced on a computer.
+ Enhanced	The D40 & D40x will enrich colours to make them appear more vivid. Best suited to pictures that will be printed without further saturation adjustment on a computer.

Manually adjusting image optimization: saturation

1) Saturation controls the vividness of colours and can be used to enhance your images. From the shooting menu, select Optimize Image and, using the multi-selector, highlight and select Custom. A custom menu will appear.

2) Select Saturation and choose from: A Auto (default) – suits saturation to the subject (best with G- or D-type lenses); 0 Normal – records natural vividness; – Moderate – reduces saturation; or + Enhanced – makes colours more vivid.

Manually adjusting image optimization: hue adjustment

The hue control function allows you to add an amount of colour cast in a range of $-9°$ to $+9°$, in increments of 3°. Red is the base colour 0°; raising the level of hue above 0° will add a yellow colour cast, making colours that appear red look more orange. Reducing the level of hue adds a blue colour cast. The greater the degree of change, the stronger the effect.

1) From the shooting menu, select Optimize Image. Use the multi-selector to highlight and select Custom.

2) Select Hue adjustment from the custom menu and press the multi-selector up, to increase the hue, or down, to reduce the hue. Press **OK** to select.

Image quality

The Nikon D40 & 40x are capable of recording images in five different quality settings: NEF (RAW); JPEG fine; JPEG normal; JPEG basic and NEF (RAW) + JPEG basic. The setting you opt for will depend on how you intend to use the final image. A JPEG (Joint Photo Experts Group) is a compressed file that receives a high level of processing by the camera and does not require post-processing using a computer (adjusting contrast, white balance, etc). JPEGs are smaller than NEF (RAW), so will take up less space on the SD card. NEF (RAW) files are unprocessed data, where the shooting parameters are attached to the image – but not applied. This allows photographers to accurately fine-tune pictures during post-processing. Although the D40 & D40x still compress NEF files, it is a lossless form of compression, so all the raw information is retained. In contrast, JPEGs are a compressed format so some of the original data will be discarded, leading to a loss in quality. Although shooting in JPEG is generally considered more practical – due to the smaller file sizes and resulting faster write times – for optimum picture quality and versatility NEF (RAW) is preferable.

Setting image quality

Image quality can be set in two ways.

1) From the shooting menu, highlight and select Image Quality using the multi-selector.

2) From the image quality menu, highlight and select the option required.

1) Alternatively, depress the **i** button whilst the shooting information screen is displayed.

2) Using the multi-selector, scroll until Image quality is highlighted. Press **OK**. The Image Quality submenu will be displayed.

3) Using the multi-selector, highlight and then select the desired setting. The relevant file size and number of remaining images will be indicated in the monitor. Press **OK** to apply setting.

Tips

Like the majority of DSLR cameras, the Nikon D40 & D40x are not capable of recording images in Tiff format. To create such a file, shoot in NEF (RAW), transfer the file to a computer and save it as a Tiff file. The remaining number of images that the inserted SD card can hold is displayed in the shooting information and viewfinder displays.

1GB capacity memory card with the D40 & D40x

Image quality	Image size	File size (MB) D40	D40x	No. of images D40	D40x	Buffer capacity D40	D40x
RAW	–	5.0	9.0	65	79	5	6
FINE	L	2.9	4.8	137	129	100	100
	M	1.6	2.7	235	225	100	100
	S	0.8	1.2	503	487	100	100
NORMAL	L	1.5	2.4	260	251	100	100
	M	0.8	1.3	444	431	100	100
	S	0.4	0.6	839	888	100	100
BASIC	L	0.8	1.2	503	487	100	100
	M	0.4	0.7	755	839	100	100
	S	0.2	0.3	1200	1500	100	100
RAW + BASIC	–/L	5.8	10.1	58	70	4	6

Image quality

Setting	Description
NEF (RAW)	High-quality, high-resolution NEF (RAW) 12-bit file, compressed to reduce size, but with no discarded data. Ideal for A3 prints or larger. Must be opened using PictureProject (supplied) or Capture NX software. Plug-ins are available for other photo editing applications.
JPEG fine	Best quality JPEG, low compressed with little original data discarded. Ideal for prints of A3 or larger. A compression ratio of roughly 1:4.
JPEG normal	Good quality JPEG, high-compressed image with some original data discarded. Good quality, suitable for photographic prints with minimal enlargement from the original. A compression ratio of roughly 1:8.
JPEG basic	Basic-quality JPEG, better suited to sending images via email or for uploading to a website, than printing. A compression ratio of roughly 1:16.
NEF (RAW) + JPEG basic	Two images are recorded simultaneously; one high-quality, high-resolution NEF (RAW) file and one JPEG recorded at basic quality. The JPEG is ideal as a quick reference or can be transmitted quickly via email.

Note
The image file size and the SD card's maximum capacity will vary depending on the subject, shooting mode, ISO speed and processing parameters.

Tip
If you intend applying a large degree of post-processing to a JPEG, first save it as a lossless Tiff file and keep the original file for reference.

Image size

The D40 & D40x have three different image size options. Image size can be set in two ways:

1) From the shooting menu, highlight and select Image Size using the multi-selector. From the menu, highlight and select the option required.

2) Or, depress the **ℹ** button whilst the shooting information screen is displayed. Using the multi-selector, scroll until Image size is highlighted. Press **OK**. The Image size submenu will be displayed. Using the multi-selector, highlight and select the desired setting.

The relevant file size and number of remaining images will be indicated in the monitor. Press **OK**.

Note
Image size can only be varied when shooting in JPEG format. When shooting in NEF (RAW), files are captured at a resolution of 3,008 x 2,000 (D40) or 3,872 x 2,592 (D40x). When NEF is selected for image quality, you cannot access the image size option.

Image size and print size

Nikon D40

Option	Size (pixels)	Approx. print size at 300dpi
Large	3,008 x 2,000	25.5 x 16.9cm (10.2 x 6.6in)
Medium	2,256 x 1,496	19.1 x 12.7cm (7.5 x 5in)
Small	1,504 x 1,000	12.73 x 8.5cm (5 x 3.3in)

Nikon D40x

Option	Size (pixels)	Approx. print size at 300dpi
Large	3872 x 2592	32.8 x 21.9cm (12.9 x 8.6in)
Medium	2896 x 1944	24.5 x 16.5cm (9.6 x 6.5in)
Small	1936 x 1296	16.4 x 11.0cm (6.5 x 4.3in)

White balance

Every light source contains the colours red, green and blue (RGB) in various proportions, depending on the colour temperature – measured in (K) degrees Kelvin. When the colour temperature is high, there is more blue; when it is low there is more red. The human eye has an impressive ability to perceive the colour temperature of different light sources and conditions as neutral. When an object is white, it appears white, regardless of the type of lighting. Digital technology isn't as advanced as the human brain, so, just like other digital cameras, the Nikon D40 & D40x need a little help to produce images with a natural colour cast. Setting the camera to AWB (auto white balance), lets the image sensor dictate white balance automatically – this is fine in the majority of situations, but manually selecting a white balance setting to match the respective light source will allow you to always achieve optimum results. For more on the colour of light, see page 125.

In addition to its auto WB setting, the Nikon D40 & D40x possess six pre-programmed WB settings that will mimic different colour temperatures. It is also designed with a customizable WB Preset.

Selecting (WB) white balance

1) White balance can be set in two ways. From the shooting menu, highlight and select White Balance using the multi-selector. From the white balance menu, highlight the option required and press **OK**. Each setting (not PRE) has a submenu which allows fine-tuning. Higher (+) settings will add a bluish tinge or compensate for light sources with a yellow or red cast. A lower (–) value will make the picture warmer or compensate for light sources with a blue cast. Adjustments can be made by moving the multi-selector up or down to select the desired value – up to a value of +3 or –3 (in increments of 1). Press **OK**.

2) Alternatively, depress the **i** button whilst the shooting information screen is displayed. Highlight White Balance and press **OK**. Highlight and select the desired setting from the white balance menu. The displayed image to the left of the setting represents the role of that particular parameter. Press **OK**.

> **Note**
> WB can only be manually set in P, S, A and M modes. In the camera's Digital Vari-Program modes, Auto is selected automatically.

White balance presets

WB setting/Colour temp. (K)	Description
A Auto (3,500–8,000K)	The Nikon D40 & D40x set WB for the prevailing lighting conditions. Use these settings for general photography.
Incandescent (3,000K)	Use for incandescent lighting, such as household lamps or street lighting.
Fluorescent (4,200K)	Use under fluorescent lighting such as stadium or strip lighting.
Direct sunlight (5,200K)	Use on cloudless days for subjects lit by direct sunlight.
Flash (5,400K)	For use with a flash unit, including the Nikon D40 & D40x's built-in flash and external Speedlights.
Cloudy (6,000K)	Use for overcast weather, diffused natural daylight, twilight or sunset.
Shade (8,000K)	Use in natural light, indoors or outdoors, when the subject is in shade.
PRE WB Preset (–)	Use a grey or white object, or an existing photograph, as a reference for WB.

Preset white balance

The D40 & D40x have a preset white balance facility to record and recall WB settings for shooting under mixed lighting or to compensate for strong colour casts. Highlight and select PRE from the white balance options in the shooting menu. Two methods are available.

WB AUTO

WB INCANDESCENT

WB FLUORESCENT

WB DIRECT SUNLIGHT

WB FLASH

WB CLOUDY

WB DIRECT SHADE

Method	Description
Measure	Neutral object, like a standard 'grey card', is placed under the lighting used in the final photograph and the WB is measured.
Use photo	White balance is copied from a photo on the memory card.

ISO sensitivity

The ISO is the numeric indication of the film or image sensor's sensitivity to light. In basic terms, the higher the ISO rating, the more sensitive the sensor is to light and therefore the less it requires to capture an acceptable image. As a result, a high ISO setting |is ideal for low light conditions or moving subjects. Similarly, the lower the ISO, the less sensitive the sensor is to light and the more appropriate it is for bright conditions and still subjects.

You can set the ISO sensitivity of the D40 to values ranging from 200 to 1600 ISO in steps equivalent to 1Ev. The D40x has an extended ISO range of 100 to 1600 ISO, also in steps equivalent to 1Ev. If a higher sensitivity is required, both models can be set to HI 1, which is the equivalent of one stop over 1600 ISO. Shots taken using the HI 1 setting are automatically processed to reduce noise, resulting in increased recording time.

Tip
In Auto and Digital Vari-Program modes, there is also an Auto ISO setting that allows the camera to automatically raise sensitivity when lighting is poor or lower sensitivity when lighting is bright. By rotating the mode dial from P, S, A or M to Auto or a Digital Vari-Program mode, the default ISO sensitivity of Auto is restored.

Setting the ISO

1) The ISO can be set in two ways. From the shooting menu, highlight and select ISO sensitivity using the multi-selector. From the ISO sensitivity menu, highlight the option required and press **OK**.

2) Alternatively, depress the **i** button whilst the shooting information screen is displayed. Using the multi-selector, scroll until ISO sensitivity is highlighted. Press **OK**. The ISO sensitivity menu will be displayed. Using the multi-selector, highlight and select the desired setting. The displayed image to the left of the setting represents the role of that particular parameter. Press **OK**.

Tip
If employing an ISO setting of 800 or above, noise will become increasingly obvious and degrade image quality. Turn on the camera's noise reduction facility (page 85).

Noise reduction

Although digital image-sensors are not affected by the failure of the law of reciprocity in the way film is, during long exposures (of two seconds or more) sensors begin to generate increased noise (page 128). This can be particularly noticeable in dark areas of the frame. The Nikon D40 & D40x boast very low levels of noise, but it is still wise to switch on the camera's noise reduction function when appropriate. This is designed to process images to reduce noise.

Using high ISO ratings can also result in greater noise. The signal of the sensor is amplified and this increases the amount of noise; however, the increase in amplification also causes disproportionate increase in noise as the variation in the signal is also amplified at high ISOs.

As a result of using noise reduction, recording time is approximately doubled and the number of images that can be stored in the memory buffer may drop. The message 'Job nr' is displayed in the bottom of the viewfinder during processing.

Setting noise reduction

1) From the shooting menu, highlight and select Noise reduction using the multi-selector.

2) Depending on the option you require, highlight Off or On and press **OK** to apply.

FLOWER
A low ISO sensitivity will minimize the effects of image degrading noise and maximize image quality. Therefore, always set the lowest practical ISO rating for any given picture-taking situation.

Customizing your D40 or D40x

The D40 & D40x are designed with a variety of useful custom settings, which can be modified to customize the camera to suit your personal preferences and style of photography. By fine-tuning your camera in this way, you can maximize the camera's potential. Thanks to the camera's clear, simple design, each custom setting can be quickly and easily selected.

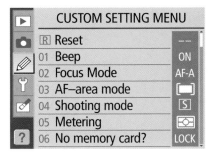

Choosing custom settings

1) Press the **MENU** button and, using the multi-selector, display the custom setting menu on the camera's monitor.

2) Press **OK** or the multi-selector to the right and, by scrolling up or down, highlight the desired group.

3) Press **OK** or the multi-selector to the right to enter that specific CS function; you can now choose between the options displayed.

4) To select a setting in a different group, return to the custom setting menu and, using the multi-selector, scroll up or down until the desired setting is displayed.

5) The custom settings are numbered 01 to 17. There is also a Reset option under the custom setting menu.

Tip
You can access help with the various uses of each custom setting by pressing the [HELP] button. When a custom setting item is highlighted in the menu or when options for a custom setting is displayed.

Custom Setting	**Reset**
Options	No; Yes.
Description	Quickly returns all custom settings to their factory default values.
Notes	A time-conserving method to restore custom settings.
Custom Setting	**01 Beep**
Options	On; Off.
Description	Controls whether the camera's beep is on or off. The current setting is displayed in the shooting information display; indicated by a musical note.
Notes	It is best to switch beep off when photographing timid wildlife, which may be disturbed by the noise.
Custom Setting	**02 Focus Mode**
Options	AF-A Auto-servo AF; AF-S Single-servo AF; AF-C Continuous-servo AF; MF Manual focus.
Description	Selects the focus mode.
Notes	AF-A Auto servo is the camera's default setting. In this mode, the camera automatically selects single-servo AF when the subject is judged to be static; and continuous-servo AF when subject is judged to be moving.

Custom Setting	**03 AF-area mode**
Options	Closest subject; Dynamic area; Single area.
Description	Select how the focus area is selected in autofocus mode.
Notes	This setting has no effect in manual focus mode.

Custom Setting	**04 Shooting mode**
Options	Single frame; Continuous; Self-timer; Delayed remote; Quick-response remote.
Description	This mode determines how the camera takes photographs: one at a time; in a continuous burst; with a timed shutter-release delay; or with a remote release.
Notes	The burst rate in continuous mode will vary depending on the model you own. The Nikon D40 is capable of 2.5fps, whilst the D40x is capable of an enhanced 3fps.

Custom Setting	**05 Metering**
Options	Matrix; Center-weighted; Spot.
Description	Determines the metering mode in P, S, A and M modes.
Notes	Matrix metering is automatically set by the camera when one of its Digital Vari-Program modes is selected.

Custom Setting	**06 No memory card**
Options	—
Description	Release locked; Enable release.
Notes	The shutter-release button is disabled when no card is inserted. This allows you to take photographs without using a memory card, although they will not be saved.
Custom Setting	**07 Image review**
Options	On; Off.
Description	In its default On setting, the D40 & D40x will display newly taken images on the monitor automatically after exposure.
Notes	Setting image review to Off, will help conserve battery power; images can still be displayed on the monitor by pressing the ▶ button.
Custom Setting	**08 Flash level**
Options	−3; −2.7; −2.3; −2.0; −1.7; −1.3; −1.0; −0.7; −0.3; 0.0; +0.3; +0.7; +1.0; +1.3; +1.7; +2.0; +2.3; +2.7; +3.0.
Description	This setting controls the level of flash compensation used to vary the flash output from −3Ev to +3Ev.
Notes	Flash compensation can only be set in P, S, A and M modes. The level of compensation can be restored by selecting a level of +/−0.

Custom Setting	09 AF-assist
Options	On; Off.
Description	When On, the AF-assist illuminator will light to aid focusing in low light conditions in single-servo AF.
Notes	The AF-assist illuminator won't operate when the Landscape or Sports Digital Vari-programs are selected.

Custom Setting	10 ISO Auto
Options	Off; On; Max. sensitivity; Min. shutter speed.
Description	In the camera's default setting of Off, ISO sensitivity will remain fixed at the value selected by the user. If On is selected, ISO will be automatically adjusted by the camera. The maximum value for auto ISO sensitivity can be selected by opting for the Max. sensitivity option. In modes P and A, sensitivity will only be adjusted if underexposure would result at the shutter speed selected for Min. shutter speed.
Notes	When On is selected, the viewfinder and shooting information display show ISO-AUTO.

Custom Setting	11 Fn button
Options	Self-timer; Shooting mode; Image quality/size; ISO sensitivity; White balance.
Description	Determines the function performed by the Fn button.
Notes	At settings other than the default Self-timer option, a **Fn** icon will appear in the shooting information display to the left of the setting that can be adjusted by pressing the Fn button and rotating the command dial.

Custom Setting	**12 AE-L/AF-L**
Options	AE/AF lock; AE lock only; AF lock only; AE lock hold; AF-ON.
Description	This custom setting determines which function is performed by the AE-L/AF-L button.
Notes	Select the setting best suited to your style of photography.

Custom Setting	**13 AE lock**
Options	Off; On.
Description	In its default setting of Off, pressing the shutter-release button halfway will not lock exposure. Select On, to lock exposure when shutter-release button is semi-depressed.
Notes	

Custom Setting	**14 Built-in flash**
Options	TTL; Manual.
Description	Choose a flash control mode for the built-in flash or for the optional SB-400 speedlight.
Notes	A submenu of flash values is displayed when Manual is selected. The flash will fire at the level chosen.

Custom Setting	**15 Auto off timers**
Options	Short; Normal; Long; Custom.
Description	Select how long the monitor and exposure meters remain on when no operations are performed.
Notes	Opt for a shorter auto off delay to preserve battery life.

Custom Setting	**16 Self-timer**
Options	2s; 5s; 10s; 20s.
Description	Varies the self-timer between 2s, 5s, 10s (default) and 20s.
Notes	If you are using the self timer to minimize camera shake on a tripod, select a short time delay of 2s.

Custom Setting	**17 Remote on duration**
Options	1min; 5min; 10min; 15min.
Description	Determines how long the camera will wait for a signal from the remote before cancelling delayed or quick-response remote modes.
Notes	The default setting is one minute. Opt for shorter times for longer battery life.

The setup menu

The setup menu controls 16 different options which can be used to control the basic parameters of how the D40 & D40x operate, including LCD brightness, auto image rotation and formatting memory cards.

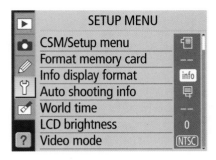

Choosing custom settings

This setting allows you to vary the options displayed in the menus. You can either opt for: Full – lists all 16 settings from the setup menu; Simple – displays a revised list of 10 basic options; or My menu – which allows you to customize any of the camera's menus to only include the settings you require and use.

To set the option you require
1) From the setup menu, select CSM/Setup menu. Use the multi-selector to highlight and select the option you require.

To select menu items for display using My menu
1) From the setup menu, select CSM/Setup menu and, using the multi-selector, highlight and select My menu. A list of menu names will be displayed.

2) Select the menu you wish to customize from the playback menu; shooting menu, custom setting menu; setup menu and retouch menu.

3) Using the multi-selector, scroll up and down to highlight items. To select and deselect items, press **OK** or the multi selector to the right. Selected items will be indicated by a tick with the adjacent box.

4) When finished, highlight and select Done at the top of the list. You will return to the menu list. Repeat the previous steps to edit additional menus.

5) Finally, highlight and select Done in the list of menu names to return to the setup menu.

Note
When using the My menu option to customize the items displayed in the camera's menus, CSM/Setup menu cannot be selected.

Format memory card

Before using an SD card in your Nikon D40 or D40x, it is recommended that it is formatted first. This is also an effective way to erase all data (included protected images) in preparation for re-use. SD cards are equipped with a write protection switch to prevent accidental damage. If this is in the 'lock' position, the camera will display a message saying memory card cannot be formatted.

1) Using the multi-selector, highlight and select Format memory card from the setup menu.

2) The message '! All pictures on memory card will be deleted. OK?' will be displayed. Highlight and select Yes to format the card or No to return to the setup menu.

Tip
Do not turn the camera off, or remove the battery or memory card, until formatting is complete – and the new number of exposures remaining is displayed in the viewfinder and shooting information displays.

Info display format

Using this option, you can customize the look of the shooting information display formats for the Digital Vari-programs and P, S, A and M modes. There are three options: Classic; Graphic and Wallpaper. The design of the Wallpaper format is the same as the Graphic option, except that a user-selected photograph can be displayed in the background, the background colour for the menus is different and the graphic representation of the shutter speed and aperture is not displayed.

To select Info display format
1) Using the multi-selector, highlight and select Info display format from the setup menu.

2) Highlight and select either; Digital Vari-Program; P, S, A, M or Select Wallpaper.

3) If you select either the Digital Vari-Program or P, S, A, M options, a submenu will be displayed. Select and highlight the option you require for shooting information display from Classic, Graphic and Wallpaper.

To choose a photograph for the Wallpaper format

1) Using the multi-selector, highlight and select Info display format from the setup menu.

2) Highlight and select Select Wallpaper. The photographs on the inserted memory card will be displayed.

3) Using the multi-selector, scroll left or right to highlight an image. If you wish to view the highlighted photograph full screen, press and hold the 🔍 button.

4) Press **OK** to select the highlighted image and return to the setup menu.

Auto shooting info

Using this option, you can determine whether to display shooting information automatically in the monitor in Digital Vari-Progam or P, S, A and M modes. Select On, to display shooting information automatically after the shutter-release button is released. If Custom setting 07 (image review) is off, shooting information will still be displayed after a photograph is taken.

1) Using the multi-selector, highlight and select Auto shooting info from the setup menu.

2) Highlight and select either Digital Vari-Program or P, S, A and M. From the resulting submenu, highlight and select On or Off, depending on the option you require.

Tip
Ensure Auto shooting info is turned on if you find yourself regularly checking camera settings.

Note
Even if On is selected for the Auto shooting info option, the monitor will switch off when the shutter-release button is pressed.

World time

1) Highlight and select World Time from the setup menu. Highlight and select Time zone and use the multi-selector to scroll through to the relevant time zone. Press **OK**.

2) To set the date, highlight and select Date from the world time menu. Set the date by using the multi-selector. Scroll left or right, to highlight either the year; month; day; hour; minute or second, and up or down to alter the value of the highlighted option.

The date and time are powered by an independent, rechargeable battery, which is charged when the main battery is installed or if the D40 or D40x are powered by the optional EH-5 AC mains adapter. If the message 'Clock not set' is displayed, then the clock battery is exhausted and you will need to reset the date and time.

Tip
You can also alter the format of the date. Do this by selecting Date Format in the world time menu and select the setting you prefer. If you wish to switch daylight saving time on or off, select Daylight saving time in the world time menu and then highlight and select the setting you require.

LCD brightness

The LCD monitor can be adjusted to one of five levels, particularly useful when playing back images (page 64).

1) Using the multi-selector, highlight and select LCD brightness from the setup menu. The LCD brightness screen will appear.

2) Looking at the chart, press the multi-selector up, to increase brightness, or down to decrease brightness. +2 is the brightest setting and −2 the darkest. Make your selection and press the multi-selector to the right or press **OK** to complete.

Video mode

Before connecting the Nikon D40 & D40x to a video device, such as a television set or VCR, select a video mode to match the standard used in the device.

1) Highlight and select Video mode from the setup menu.

2) Highlight and select either NTSC or PAL depending on the standard of the device you are connecting to.

Language

You can select the language in which camera menus and messages will be displayed. Choose from 15 different languages using the language menu.

1) Highlight and select Language from the setup menu. Using the multi-selector, scroll through the languages available and highlight and select your preferred choice.

Image comment

When you take pictures using the D40 or D40x, you can add brief text comments to the image file which can later be viewed in Nikon Capture NX (optional) or PictureProject software. Comments can be up to 36 characters long – any additional characters will be deleted.

1) Highlight and select Image comment from the setup menu.

2) Select Input comment. An alphanumeric keypad and comment area will be displayed on the monitor.

3) To add or edit a comment, use the multi-selector to shift the cursor around the keypad and press **OK** to select the characters.

4) To deselect characters, move the cursor over the desired letter or number in the name area by rotating the command dial. Press the 🗑 button to erase that character.

5) Once the desired comment has been entered, press the 🔍 button to save changes and return to the image comment menu.

6) Select Attach comment to add the newly entered/edited comment to all images taken while this option is checked. Finally select Done to return to the setup menu.

7) To deselect Attach comment, highlight and select Attach comment and press **OK** or the multi-selector to the right to uncheck the box.

Operating system	USB
Windows Vista (32-bit Home Basic/Home Premium/ Business/Enterprise/Ultimate editions) Windows XP (Home Edition/Professional)	Choose **MTP/PTP** or **Mass storage**
Mac OS X version 10.3.9 or 10.4.x	
Windows 2000 Professional	Choose **Mass storage**

USB

The USB connection type must match the device and software being used in conjunction with the camera. The appropriate setting should be set before the camera is attached to the computer or printer. Choose PTP when connecting to a PictBridge printer or using Camera Control Pro (available separately).

1) The default setting for USB is Mass Storage. To alter the setting, highlight and select USB in the setup menu. Use the multi-selector to highlight and select the required connection type; either Mass Storage or PTP.

Tip

Use the Folders option in the setup menu to rename folders. Highlight and select the desired folder from the list and, using the keypad, edit as required. It is also possible to delete empty folders on the inserted memory card.

Folders

It is possible to create, rename or delete folders, or choose the folders in which new photographs will be stored.

Create a new folder
1) Highlight and select Folders from the setup menu.

2) Highlight and select New. In the Keypad area displayed, use the multi-selector to highlight characters. Press **OK** to select character.

3) Folder names can be up to five characters long. To delete or edit characters, highlight the letters or numbers in the name area by rotating the command dial to move the cursor. Press the 🗑 button to erase highlighted character.

4) Press the ⊕ button to save changes and return to the setup menu. Subsequent images will be stored in this folder.

Select folder

1) Highlight and select Folders from the setup menu.

2) Highlight and select the Select folder option. Using the multi-selector, highlight the folder name (listed alphabetically) required. Press **OK**, or the multi-selector to the right, to store subsequent images in the selected folder and return to the setup menu.

Note
On the memory card, folder names are preceded by a three-digit folder number assigned by the camera e.g. 100NCD40. Each folder can contain up to 999 images. Images are stored in the highest-numbered folder with the selected name. If a photograph is taken when the current folder is already full, or contains a photograph numbered 9999, the camera will create a new folder by adding 1 to the current folder number, e.g.101NCD40.

File No. Sequence

The D40 & D40x give each picture taken a file name consisting of 'DSC_' followed by a four-digit file number. This is followed by a three-letter extension to indicate the file type: either JPG (JPEG) or NEF (RAW). Subsequent images are numbered by adding one to the current number, up to 9999. When the File No. Sequence option is Off, file numbering is reset to 0001 when a new folder is created, the memory card is formatted, or a new memory card is inserted. When it is switched On, file numbering will continue from the last number. It is also possible to Reset File No. Sequence. By doing so, numbering will return to 0001 with the next image taken – if the current folder already contains photographs, the camera will automatically create a new folder.

1) Highlight and select File no. sequence from the setup menu.

2) Highlight and select the option you require from Off, On and Reset. You will return to the setup menu.

Note
Photographs recorded using a Color mode setting of II (AdobeRGB) begin with an underscore (e.g. '_DSC'). Small copies, created via the Small picture option in the retouch menu, are given file names beginning with 'SSC_'. Other images created via the retouch menu begin with 'CSC_'.

Mirror lock-up

The reflex mirror can be locked in the up position to allow access to the low-pass filter that protects the CCD – for inspection or cleaning.

1) Remove the lens and turn the camera on. Highlight and select Mirror lock-up from the setup menu. Select On to continue. The message 'When shutter button is pressed, the mirror lifts and shutter opens. To lower mirror, turn camera off' will appear. Or, select Off to return to the setup menu.

2) Depress the shutter-release button all the way down, as if taking a picture. The mirror will be raised and shutter curtain will open, revealing the low-pass filter. Switch the camera off to lower mirror.

Cleaning the low-pass filter
The low-pass filter minimizes moiré (page 127) and also helps prevent foreign matters adhering directly to the image sensor. However, over time dust will inevitably settle on the filter, appearing as dark spots on your images. It is possible to clean the area by locking the mirror up and using a

blower. It is important to remember that the low-pass filter and sensor are delicate components and need to be treated with great care. It is also crucial that there is sufficient battery power to perform this operation. The shutter curtain is easily damaged and if the camera powers off while the mirror is raised, the shutter will close automatically. The camera will beep and the AF illuminator will blink to warn when the battery is running low, but it is advisable to use either a fully charged battery or an EH-5 AC adapter to prevent the camera from running out of power mid-clean.

1) With the mirror locked in the up position, hold the camera so that light falls on the low-pass filter and examine the filter for dust.

2) Carefully use a blower (not a brush) to remove any dust or debris from the filter. Do not touch or wipe the filter. To end the cleaning session, turn the camera off. This will close the shutter and the mirror will return to its original position. To resume taking pictures, switch the camera back on.

Firmware version

New firmware is released from time to time to improve the performance of the camera and can be downloaded from the Nikon website (page 221).

1) To view the firmware version, select Firmware version from the setup menu. Press **OK** or the multi-selector left to return to the setup menu.

Auto Image Rotation

Photographs taken when On (the default setting) is selected will contain information on camera orientation. As a result, they will be rotated automatically during playback. When off is selected, images are displayed in landscape (wide) format, regardless of the camera's orientation at the time of capture.

1) Select and highlight Auto image rotation from the setup menu and select either On or Off.

In continuous shooting mode the picture orientation for the first image will be applied to all images in the same burst – even if camera orientation is altered during shooting.

Dust off ref photo

To reduce the effects of dust, the D40 & D40x, in conjunction with (optional) Nikon Capture NX software, compare a NEF (RAW) image with a reference image created by the camera. It will then process images to remove the effects of dust in the camera imaging system by comparing the image with the reference shot acquired.

Note

If the reference object is too bright or too dark, the camera may be unable to acquire the image dust off reference data and the message 'Exposure settings are not appropriate. Change exposure settings and try again' will be displayed. Choose a different reference object and try again. The same shot can be used for NEF (RAW) images taken with lenses of different focal lengths.

1) Attach a CPU lens to the camera (a focal length of 50mm is recommended). If using a zoom lens, zoom to its maximum focal length. Highlight and select Dust off ref photo from the setup menu. Select On. The message 'Take photo of bright featureless white object 10cm from lens. Focus will be set to infinity' will be displayed and rEF will be shown in the viewfinder display.

2) With the lens 4in (10cm) from a bright, white plain object, frame the picture so that nothing else is visible through the viewfinder and press the shutter-release button halfway. In AF mode, focus will automatically be set to infinity; in manual focus mode, set focus to infinity manually. Fully depress the shutter-release button to acquire image dust off reference data. The monitor will turn off when the shutter-release button is pressed.

The retouch menu

The Nikon D40 & D40x are designed with a variety of innovative features. The retouch menu is a relatively new concept; inherited from the D40's bigger brother the D80. It is designed to give photographers the ability and versatility to 'retouch' images in-camera. Nikon has provided a useful range of retouching options, including Red-eye correction, Trim, Monochrome and Filter effects. Retouching always results in a new image being created – the original file remains unaltered. Retouching

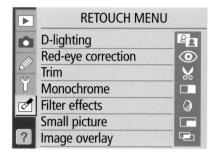

can be applied to JPEG or NEF (RAW) images. Copies created from RAW images are always in JPEG form; 3,008 x 2,000 pixels (D40) or 3,872 x 2,592 (D40x) in size.

D-lighting

This retouching option is designed to brighten shadows, making it perfectly suited for dark or backlit photographs. Three options can be applied in the D-lighting edit menu: Normal; High and Low.

1) Highlight and select D-lighting from the retouch menu. Using the multi-selector, scroll left or right to highlight the image you wish to retouch. To view highlighted images full frame, press and hold the 🔍 button. Press **OK** to select. Alternatively, view the image in full-frame playback and press **OK**. Highlight and select D-lighting from the menu displayed.

2) In the D-lighting edit menu, the selected image will be displayed alongside a copy. Press the multi-selector up or down to choose the amount of correction performed. The effect is previewed on the copy image.

3) Press **OK** to save the copy – and apply the effect – and return to full-frame playback.

> **Note**
> With the exception of Image overlay, photographs to be retouched can be selected either via the retouch menu or from full-frame playback.

Red-eye correction

Red eye is the eerie red glow that appears in human eyes – and some animals – in photographs taken using flash in dimly lit areas. It occurs when the light from a flash unit bounces off the blood vessels lining the retina of the eye. The D40 & D40x's Red-eye correction feature is designed to create a corrected copy of pictures that suffer from this common complaint. Red-eye correction is only available with photographs taken with flash.

Notes
Red-eye correction may not always produce the desired or expected results. In rare circumstances, it may even be applied to portions of the image that are not affected by red eye. Therefore, check the previews thoroughly before proceeding.

If the camera cannot identify red eye in the selected image the message 'Unable to detect red eye in selected image' will be displayed.

1) Highlight and select Red-eye correction from the Retouch menu. Using the multi-selector, scroll left or right to highlight the image you wish to retouch. To view highlighted images full frame, press and hold the ⊕ button. Press **OK** to select. Alternatively, view the image in full-frame playback and press **OK**. Highlight and select Red-eye correction from the menu displayed.

2) Use the ⊕ and ⊖ buttons to zoom in or out of the picture. Using the multi-selector, scroll around the image to view areas not visible in the monitor.

3) If the camera detects red eye in the selected photograph, press **OK** to create a copy that is processed to reduce its effects.

Tip
With the exception of photographs created using Small picture, the options in the retouch menu can be applied to existing copies. However, this may result in a loss of quality. Each retouch option can only be applied once.

Trim

Using the retouch menu, it is possible to 'trim' images in-camera. Resizing a photo by cropping out unwanted areas of the image can vastly enhance some images, improving composition and heightening the impact of an image by removing uninteresting portions. However, remember that when you crop an image you are also deleting image data.

1) Highlight and select Trim from the retouch menu. Using the multi-selector, scroll left or right to highlight the image you wish to retouch. To view highlighted images full frame, press and hold the ⊕ button. Press **OK** to select.

2) Alternatively, view the image in full-frame playback and press **OK**. Highlight and select Trim from the menu displayed.

3) Use the ⊕ and ⊖ buttons to zoom in or out of the picture. Using the multi-selector, scroll around the image to view areas not visible in the monitor.

4) By zooming in and out and scrolling, compose your new image. Press **OK** to save the area currently visible in the monitor as a copied file and return to full-frame playback.

Tip
Whilst Trim is a useful feature, creative cropping can be applied with greater precision during post processing using photo editing software.

Note
Copies created from NEF (RAW) or NEF (RAW) + JPEG have an image quality of Fine. Trimmed copies created from JPEG photos have the same image quality as the original. However, depending on the size of the crop, the copy will be either 2,560 x 1,920; 1,920 x 1,440; 1,280 x 960; 960 x 720 or 640 x 480 pixels in size (for both the D40 & D40x).

LAMBS
Using the Trim option, it is possible
to eliminate distracting elements from
the frame, or place more emphasis on
the main subject.

Monochrome

The term monochrome not only refers to black and white (or more commonly greyscale), but also other combinations containing just two colours. It can also refer to sepia (reddish-brown toned) or cyanotype (cool blue toned) images.

Black and white photography remains a powerful and popular medium, and via the retouch menu, it is possible to quickly transform your colour shots into Black-and-white, Sepia or Cyanotype. The advantage of converting colour images, as opposed to shooting in black and white originally via Optimize image (page 69), is that you have a colour version which is useful if you later decide that you don't like the monochrome effect.

1) Highlight and select Monochrome from the retouch menu. Using the multi-selector, highlight and select either Black-and-white; Sepia or Cyanotype – depending on the effect you desire.

Note
D-lighting, Red-eye correction, Monochrome and Filter effects are not available with photographs captured when Black-and-white is selected for Optimize image (page 69).

2) Using the multi-selector, scroll left or right to highlight the image you wish to retouch. Press **OK** to select and view a full-frame preview of the effect.

3) Press the multi-selector up, to darken the monochrome effect, or down, if you wish to lighten the effect.

4) When you are happy with the effect, press **OK** to save a copy or the ▶ to cancel.

Tip
You can also apply Monochrome via full-frame playback. With the required image displayed on the monitor, press **OK**. Highlight and select Monochrome from the retouch menu displayed. Using the multi-selector, highlight and select Black-and-white, Sepia or Cyanotype – depending on the effect you require. Colour saturation can be increased or decreased by pressing the multi-selector either up or down. Finally press **OK** to save the image as a copy, or the ▶ button to cancel the effect and return to full-frame playback.

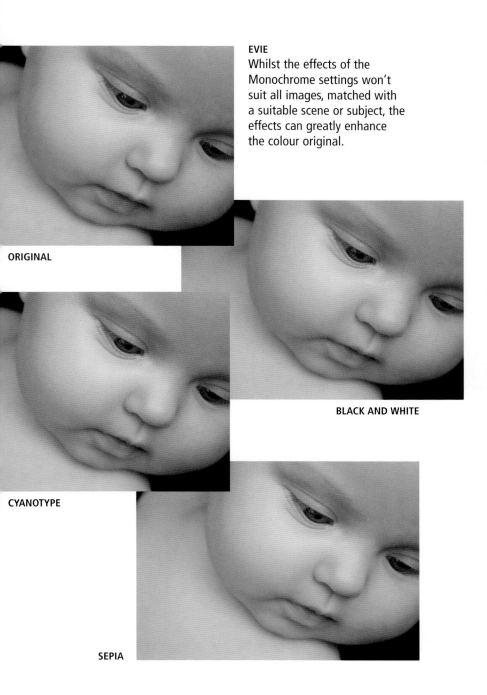

EVIE
Whilst the effects of the Monochrome settings won't suit all images, matched with a suitable scene or subject, the effects can greatly enhance the colour original.

ORIGINAL

BLACK AND WHITE

CYANOTYPE

SEPIA

Filter effects

Whilst tradition optical filters remain important photographic accessories, the innovative D40 & D40x are designed to simulate the effect of some filters – saving you the expense of investing in the genuine article.

Three filter effect options are available under the retouch menu.

Skylight
This effect is intended to replicate a skylight filter, reducing bluish casts created by high altitudes.

Warm filter
Traditional warm-up filters are designed to add warmth to images, which often proves flattering. The option creates a copy with a warm tone filter effect applied.

Color balance
This option allows you to manually adjust the hue of the image for creative or corrective purposes. Press the multi-selector up, to increase green; right, to increase red; left, to increase blue or down, to increase the level of magenta. The effect is displayed in the monitor together with red, green and blue histograms showing the distribution of the tones in the copy.

1) Highlight and select Filter effects from the retouch menu.

2) Using the multi-selector, highlight and select either Sky light, Warm filter or Color balance – depending on the effect you desire.

3) Using the multi-selector, scroll left or right to highlight the image you wish to retouch. Press **OK** to select and view a full-frame preview of the effect – or, if you select Color balance, display the colour balance menu.

4) If you are happy with the effect, press **OK** to save a copy. Alternatively, press the ▶ to cancel.

Tip
You can also apply Filter effects via full-frame playback. With the required image displayed on the monitor, press **OK**. Highlight and select Filter effects from the retouch menu displayed. Using the multi-selector, highlight and select Sky light, Warm filter or Color balance – depending on the effect you require. When you are happy with the applied filter effect, press **OK** to save the image as a copy. Alternatively, press the ▶ button to cancel the effect and return to full-frame playback.

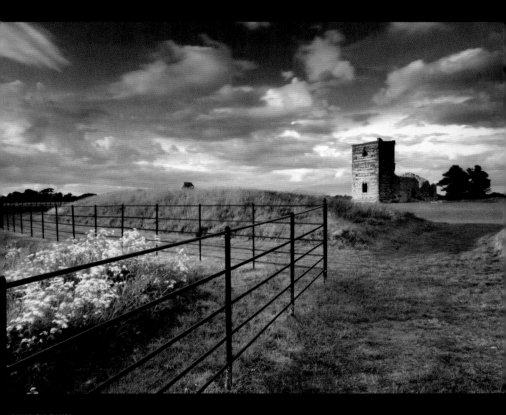

CHURCH RUIN
Traditional, optical warm-up filters are used to add a flattering warm tone to photographs. However, using the D40 & D40x, it is possible to replicate their effect in-camera without the cost of buying a separate filter.

Small picture

This option is designed to allow you to create a small copy of the selected image. Multiple images can be resized at one time. The following options are available.

640 x 480 pixels: suited to television playback.
320 x 240 pixels: suited to web page display.
160 x 120 pixels: suited for email.

1) Highlight and select Small picture from the retouch menu.

Tip
Single Small picture copies can be created via full-frame playback. This is a quick, convenient option when you do not wish to create multiple resized images. With the required image displayed on the monitor, press **OK**. Highlight and select Small picture from the retouch menu displayed. Using the multi-selector, highlight and select the picture size you require from the three options shown. The message 'Create small picture?' will be displayed. Highlight and select Yes, to create a copy; or No, to return to the picture size options. To return to full-frame playback without creating a copy, press the ▶ button.

2) Select Choose size and, from the submenu, highlight and select either 640x480, 320x240 or 160x120 – depending on the option you require.

3) Now, choose Select picture. Using the multi-selector, scroll through the images. To view highlighted images full frame, press and hold the ⊕ button. Select images to be resized by pressing the multi-selector up or down. Selected images will be indicated by a ⊡ icon.

4) Repeat step 3 if you wish to select multiple images for resizing. When finished press **OK**.

5) The message 'Create small picture?' will be displayed, with the number of images selected shown underneath. Highlight and select Yes, to save copies, or No, to return to picture selection. Alternatively, press the **MENU** button to exit to the retouch menu without creating small picture copies.

Note
Small pictures are indicated by a grey border during full-frame playback. The playback zoom is not available when small pictures are displayed.

Image overlay

Using Image overlay, the Nikon D40 & D40x can create a new image by combining two existing NEF (RAW) photographs into a single image. The new image will be saved separately from the original images. The new image is saved at current image quality and size settings. In order to use this function, both of the original shots must be on the same memory card, and there must be sufficient room for the resulting composite.

1) Highlight and select Image overlay from the retouch menu. A preview will be displayed with Image 1 highlighted.

2) Press **OK** to view the NEF (RAW) images on the inserted memory card. Use the multi-selector to highlight images. To view highlighted images full frame, press and hold the Q button.

3) Press **OK** to select highlighted image. The image will appear as Image 1.

4) Press the multi-selector up or down to select a value for gain between 0.1 and 2.0. The default value is 1.0, whilst selecting 0.5 cuts gain in half and 2.0 will double gain. The effects of gain are visible in the preview image.

5) Use the multi-selector to highlight Image 2. Repeat steps 2–4 to select and adjust the gain of the second image.

6) Finally, use the multi-selector to highlight and select the preview column. Select Overlay, to preview the result full frame before saving; or Save, to save your new composite. Once an Overlay is created, the camera will enter full-frame playback with the new picture displayed in the monitor.

Note
The Overlay image will adopt the same shooting information – including date, metering, shutter speed, aperture, exposure mode, exposure compensation, focal length, image orientation and white balance – as the photograph selected for Image 1.

Tip
Only NEF (RAW) images taken with the D40 or D40x can be selected for Image overlay. Other images, JPEGs for instance, will not be displayed in the thumbnail gallery.

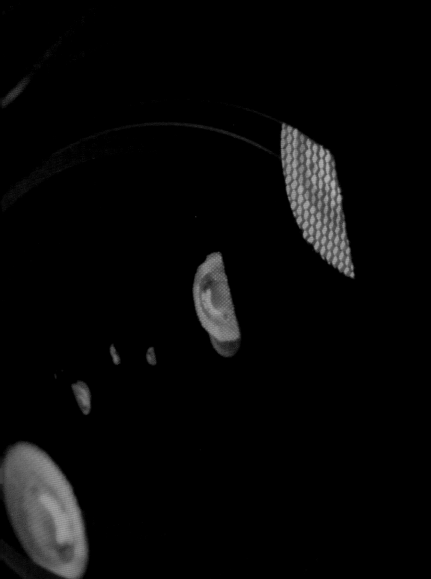

Chapter **3**

Into the field

The reality of digital technology is that anyone who can point a camera and turn a few dials can take a snapshot. In many instances, these pictures are adequate record shots, but a truly memorable photograph is the result of a combination of technical and creative ingredients.

SANDYMOUTH BAY, CORNWALL, UK
A good understanding of light is vital to photography. This, combined with a creative eye and good composition, will help your images stand out from the crowd.

Firstly, an aspiring photographer must wrest creative control back from the camera by learning to master its various modes and menus (Chapter 2). After that must come the development of a creative eye – something that grows from studying the work of other photographers and evaluating your own pictures. The final stage is a combination of the two skills, using the camera as a tool to communicate your vision.

The following chapter will help you understand digital and optical properties as well as depth of field, lighting, motion and composition in order to produce great images. Taking full creative control will result in images that reach way beyond the basics.

Depth of field

Depth of field refers to the area in an image, from front to back, that appears acceptably sharp. Only the element you have chosen to focus on – and anything else that falls along the same focal plane – will be perfectly in focus, but a certain area in front of and behind your chosen subject will also appear to be sharp. Depth of field is a crucial creative tool: shallow depth of field will throw the background and foreground out of focus, reducing the impact of any distracting elements within the frame, while extensive depth of field will give detail from front to back and is often applied to landscape shots.

Depth of field can be controlled by altering the aperture; the focal length of the lens; the subject-to-camera distance; or the chosen focal point. The main control of the depth of field in most situations is aperture. A wide aperture (a low f-number like f/1.4 or f/2.8) will result in shallow depth of field, whereas a

narrow aperture (a high f-number like f/22 or f/32) will result in extensive depth of field. Similarly, the focal length of the lens will also determine how much of an image appears sharp. Longer lenses produce a more restricted depth of field than those with shorter focal lengths, with wideangle lenses producing extensive depth of field. The distance between the camera and the object being photographed also alters depth of field – the closer you are to the subject, the less depth of field you will obtain in the image. Finally, the exact point at which you focus the lens will affect where the depth of field falls in the final image.

BLUEBELL
A wide aperture will produce a shallow depth of field, which can be utilized to isolate a subject from its surroundings. In this instance, an f-number of f/4 was selected to isolate this solitary bluebell from the others behind. However, when employing a wide aperture, accurate focusing is essential.

Depth of field extends from roughly one third in front of the point of focus to approximately two thirds behind it. There may be occasions when you want to maximize the zone of sharpness without changing the aperture, the subject-to-camera distance or the lens, in which case focus roughly one third from the bottom of your picture for the greatest window of sharpness.

The majority of cameras, including the Nikon D40 & D40x, are automatically set to the widest lens aperture to assist viewing and focusing. In order to increase depth of field, either stop down the aperture (select a higher f-number); change to a shorter focal length lens; step back from the subject or try focusing one third into the frame. To decrease the depth of field, either employ a wider aperture (select a lower f-number); change to a longer focal length lens; or step closer to the subject.

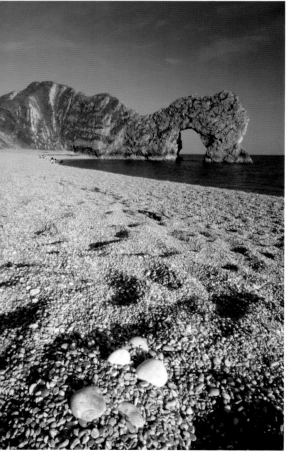

DURDLE DOOR, DORSET, UK
Focusing roughly a third from the bottom of the frame will maximize the available depth of field. In this instance, focusing on the hyperfocal point has enabled me to keep everything, from the pebbles in the foreground to the rock stack in the distance, acceptably sharp.

Hyperfocal distance

There will be occasions when you require your image to be sharp from front to back; for example, when shooting a sweeping vista. Selecting the smallest aperture is a start, but a technique known as hyperfocal focusing will help maximize depth of field. To apply this, it is important to understand that depth of field always falls one third in front of and two thirds behind the point of focus. When the lens is focused on infinity the part of the zone that falls behind the point of focus is wasted. In order to render as much of the scene in sharp focus as possible, first set your camera on a tripod. Next, select the minimum aperture available on the lens you are using. Focus the lens on infinity and release the shutter. View the resulting image via the camera's playback facility and ascertain the closest point of the scene that remains acceptably sharp (known as the hyperfocal point). Finally, manually refocus the lens to this distance before taking the final shot. This method of hyperfocal focusing will ensure that you make the most of the available depth of field.

Note

Using a lens of a particular focal length on a cropped-sensor SLR, such as the Nikon D40 & D40x, will lead to an increase in the depth of field, compared to a 35mm or full-frame SLR – assuming the aperture remains the same. If you move further away from the subject – to mimic the same field of view with the D40 & D40x as you would obtain with the same lens on a 35mm SLR – the camera-to-subject distance will increase, enhancing the available depth of field. Alternatively, if the camera-to-subject distance remains the same, the available depth of field will still increase because a shorter focal length is required to retain the field of view. This is slightly countered by the fact that an image from the cropped sensor will have to be enlarged more to reach a certain size than a similar image from a 35mm frame. However, the overall effect is still a significant increase in depth of field for any given aperture.

Recording motion

There are three main ways in which to convey movement in a photo: freezing, panning and blurring. Each will create a different feel within an image and it is important that you are competent at all three techniques if you are to record motion successfully.

Freezing
In order to freeze motion in an image you need to employ a fast shutter speed. This speed will be determined by a number of factors: the rate at which your subject is passing through the frame; the direction in which it is moving; and the focal length of the lens attached. For example, if a man is running parallel with the viewfinder he will be moving more slowly across the frame than, say, a moving car. As a result, the minimum shutter speed you will need to adopt to freeze the runner will be slower than that for the car, but faster than if the man were walking. If the runner is jogging towards the camera he will be crossing less of the sensor plane, and therefore will require a slower shutter speed to be rendered sharp, than if he were running across the frame. Using a long focal length will mean the subject is larger within the frame, therefore moving proportionally faster within the frame than if you were using a short focal length. It is common practice to select the highest shutter speed that light levels will allow to prevent blur from occurring.

Blurring
Blur is most commonly used in landscape photography where flowing water is often recorded as a milky wash to emphasize its movement. The most important tool is a tripod, as blur is achieved using

COAL TIT
Often, you will need to prioritize a fast shutter speed when photographing moving subjects, like birds and mammals. In this instance, I selected a shutter speed of 1/400sec to ensure this coal tit was recorded pin sharp.

slow shutter speeds, and camera shake during a long exposure will result in the whole scene blurring, rather than just the area that is moving within the frame. The shutter speed you require will depend on the speed at which your subject is moving, but 1/2sec or slower should yield good results.

Blur can also be used with flash photography; try using a slow shutter speed to create a sense of movement, and then freezing the subject with a burst of flash.

Panning

Panning involves following a subject moving from side to side, before, during and after the exposure. Using a medium shutter speed as you pan will keep the subject sharp while the background

blurs – perfect for eliminating distracting crowds at sporting events. Panning takes practice and its effect will depend on the speed at which the subject is travelling, and your distance from it. As a general rule, shutter speeds from 1/4sec to 1/30sec are a good starting point. Make sure that you follow the action even after pressing the shutter to prevent you from jerking the camera.

RIVER
By using a long shutter speed of two seconds, I have blurred the motion of the running water, producing a more atmospheric result. This is a popular technique for creating the impression of movement. However, a sturdy tripod is essential for keeping the camera still during exposure.

Tips
The autofocus of the Nikon D40 & D40x will continuously focus on a moving subject while the shutter-release button is pressed halfway, when AF-C Continuous-servo AF (page 53) is selected as the focus mode.

If you are photographing an animal moving across the frame, try to intentionally leave some empty space for the subject to fly, jump or run into.

Composition

Taking a photograph requires you to make a series of decisions, some that are conscious and others that are subconscious. From the moment you lift the camera to your eye, you are actively isolating a small slice of the scene before you. Choosing what to include and exclude is the biggest decision in the picture-making process and subsequent options will determine how effectively you communicate your vision.

What to include

Deciding what to exclude from your compositions is just as important as what you include. Although it can be tempting to cram a shot full of colour, action or scenery, it is often better to isolate smaller areas of interest by moving closer or using a longer focal length. Do experiment with cropping, but try to avoid your choices looking accidental.

Including too many elements in your composition can prove distracting for the viewer, so keep things clean and simple. Where possible, walk around your subject to explore different viewpoints and, if necessary, fill the frame with your subject to eliminate distractions.

A large number of pictures are shot from the photographer's eye-level, resulting in static images. Changing your viewpoint will give more energy and dynamism to your shots, and can help to emphasize which parts of your subject are the most important. Looking up at a subject, for example, can make it seem imposing, while looking down on one can make it seem weak or insignificant.

The background is also very important – if it competes with your main subject, the impact of the image will be reduced. If there is no way to exclude a messy background, use a shallow depth of field to throw it out of focus. Alternatively, if it adds to the photograph, then allow it to complement your subject by using a greater depth of field.

EUCALYPTUS TREE
Unusual shooting angles will often create more interesting, dynamic looking results. Here a low viewpoint has emphasized the height of this tree, making it appear more imposing.

LEAF
When I photographed this backlit leaf, I intentionally positioned its major vein so it cut diagonally across the frame. As a result, the composition is far stronger and visually more interesting than if it had been placed to cut through the middle of the image, top to bottom.

Finding balance

Often we will look at a photograph and find it aesthetically pleasing without knowing exactly why. Mostly this is a simple case of the photographer's natural ability to create a well-balanced image. Studying the work of graphic designers and artists will help you to judge when your composition is balanced. To begin with, consider how each element within your image relates to the rest. What you choose to give importance to, and which aspects you decide to 'play down' will instruct your audience how to view the image. For example, dark objects appear visually heavier than lighter objects: large objects have more presence than smaller ones; and an object to one side of the frame will seem to have more weight than one positioned in the centre. Think about what attracted you to the subject in the first place, and make this your chief focus. Consider your use of negative space – is your subject becoming overpowered by empty space? Similarly, look for lines and shapes: diagonals suggest movement and will add dynamism to your composition; horizontal lines indicate calmness and stability; vertical lines suggest strength; and curved lines hint at gracefulness and slowness. Next, look for repetition, pattern and symmetry, which can be used to great effect.

The pursuit of balance will yield excellent pictures in the majority of instances, but also remember that intentionally unbalanced compositions can be equally pleasing. Breaking the 'rules' of composition is important and fun, but to do this you still have to learn them first.

Directing the eye

When viewing an image we naturally tend to 'read' the information from left to right, or from the bottom to the top of the frame; it can be useful to use a lead-in line to guide the viewer through the composition. Commonly used in landscape photography, a lead-in line can be anything from an avenue of trees, to the shape of a river or road. Directing the viewer's eye will ensure the elements are viewed in the order you intend, helping to communicate your vision.

Another way of guiding the viewer's eye through the image is with selective focusing. The eye tends to settle on areas that appear sharp in an image; consequently, it is crucial that your point of focus is chosen carefully. When shooting portraiture, for example, ensure that the subject's eyes are sharp. Alternatively, when composing a scenic image, all of the elements may be just as important as each other, so you might want to ensure everything from front to back is sharp (page 115). Landscape images can also be more effective when they include an element of 'foreground interest', perhaps flowers, a rock or a stream.

The final visual signposting you can use is colour. Bright areas will attract the viewer's eye more than dull hues; some colours, such as red and orange, give a feeling of warmth, while others, such as blue and white, are cooler. Harmonious colours are reassuring, whereas conflicting colours create tension.

STORMY EVENING LIGHT
Foreground interest is a key ingredient to scenic images. In this instance, I utilized a stone wall to add interest to the image and help create the feeling of depth.

DARTMOOR VIEW
The rule of thirds is an effective technique, especially well suited to scenic photography. Here I have intentionally positioned the skyline so that one third of the frame is sky and two thirds is landscape. This places greater emphasis on the foreground, creating a more attractive composition.

Rule of thirds

The rule of thirds is a basic, but effective, compositional technique. To apply it, divide the frame in your mind with vertical and horizontal lines at one-third intervals. To achieve a balanced composition, your main subject should fall where the lines intersect. This is an effective and useful guideline, but keeping to the 'rules' too rigidly can stunt your own style, so, remain open and flexible to other possibilities.

Where you place your subject within the frame will influence the viewer's perception of a scene. Placing it directly in the centre can be effective, but it can seem isolated from other elements in the picture or appear static. A more popular option is off-centre placement.

The position of the horizon will have a profound effect on a landscape image. Slicing the frame in half places equal emphasis on sky and land. Placing it towards the bottom will imply that the sky is more important, and towards the top will emphasize the land; the latter two options are generally regarded to be the most effective.

Tips
When photographing animals, or a moving subject, leave space for them to 'move' into. Similarly, with portraiture, the viewer will often follow the gaze of the subject, so leave room for them to look into.

Lighting

Without doubt, light is the most important element of photography. The word photograph derives from the Greek 'photo' (meaning light) and 'graphe' (drawing). 'Drawing with light' is an apt description for the technical act of creating a photograph, but it also highlights the key role of light within the creative process.

The main features of light are contrast, direction and colour. The control that you have over the characteristics of light, particularly within the natural environment, is limited, so a good understanding of light – along with technical and compositional knowledge – is the foundation of good photography.

Contrast

Contrast is determined by the size and brightness of the light source. A small, bright light source creates intense light, while a larger or less bright source will be more subtle. Intense light will create high contrast – a large tonal difference between the highlight and shadow areas of an image.

A high-contrast source may present problems if the extremes of brightness and darkness fall beyond the camera's dynamic range. This is not a big problem if it occurs in relatively small areas, but swathes of featureless black or white should be avoided. The sensor's dynamic range is effectively greater at low ISO ratings, so if you are faced with a high-contrast situation, then try to use the lowest ISO rating possible. Use the exposure-compensation function (page 48) in conjunction with the histogram (page 60) in order to keep as much image detail within the dynamic range as possible. If none of these steps solve the problem, and you can't modify the lighting, you have the choice of overexposed highlights or underexposed shadows. While you can check

LAKE VIEW
It is the quality of the light that makes this image successful. It was taken at first light, when the low sunlight is diffused and warm.

the effect of both using the playback function, it is usually better to underexpose as black shadows look more natural than completely white highlights.

Aside from the technical problems presented by contrast you should also take aesthetics into account: a high-contrast source renders shadows well defined, while diffused lighting gives them less-defined edges. Typically, high-contrast lighting suits those subjects that have well-defined textures or shapes as the contrast will cast one side of the shape or texture into shadow, highlighting the other to emphasize texture or form. Low-contrast lighting is good for subjects that are best depicted in a relatively 'straightforward' manner, without an exaggerated emphasis on the form; particularly where the colours are the central theme, such as floral close-ups or abstracts, or where strong shadows are often unflattering, such as portraits.

Although you often have to work with the available light, there are steps that you can take to alter the scene's contrast. Consider the weather: if it is mixed, then you can wait for a cloud to cover the sun and lower the contrast or vice versa. You can revisit the spot at another time of day – or even year – when the weather most suits that particular scene. Naturally, you have a great deal of control over the contrast of artificial lighting.

CATKINS
Direct sunlight or flash would have destroyed the subtle colour and detail of these catkins, so I took the picture when they were shaded by the branches of the trees overhead.

Flash units typically create quite a high level of contrast because they are small, bright sources of light. If this creates harsh shadows then try bouncing the flash (page 152) to reduce the strength of the contrast or to hide the shadows behind the subject. Or you could trigger a number of flash units together to light a scene more evenly – this appears more natural if you vary the flash exposure compensation for each unit. The best way to soften contrast from an on-camera flash unit is to use a diffuser over the flash head.

JIGSAW PUZZLE
All types of subjects can look striking as inky silhouettes, for instance people, trees and buildings. In this instance, I placed a section of a jigsaw on a lightbox and metered for the highlights. By doing this, the jigsaw itself was grossly unexposed creating the silhouette effect I desired. I removed a piece of the puzzle to create more visual interest.

Direction

The direction of light is crucial in determining a subject's appearance and there are four broad categories: front lighting, backlighting, side lighting and overhead lighting. Each one creates different effects.

Front lighting is the easiest to handle. It illuminates the front of the subject evenly. It is good for showing subjects with no particular emphasis, but it can prove dull, lacking impact and atmosphere.

Overhead lighting creates very little form and can make subjects look flat. It can also create areas of high contrast with unpleasant shadows, but you can relieve them with fill-in flash or a reflector.

Side lighting is one of the main reasons that many photographers shoot at the beginning and end of the day. Side lighting highlights texture and form, although to what degree depends on the subject and the angle and intensity of the light source. One problem can be that if

the contrast of the lighting is greater than the dynamic range of the sensor, then the shadows or the highlights, or sometimes both, will be rendered without detail.

Backlighting can create striking effects, but it is hard to handle. The two most common forms are rim lighting and silhouetting. Rim lighting is where there is still detail rendered in the face side of the subject and a halo of light surrounds it. A silhouette, on the other hand, is an image in which the subject is rendered pure black. Backlighting is effective when the subject has an interesting outline and when the colour of the background light is spectacular. To create an effective silhouette, you should meter for the light, using the histogram to ensure that a large number of pixels are pure black. This will also mean that the colour of the light should be saturated. The technique for rim

SUNSET

Warm colours can be exaggerated by setting a high white balance setting. When I photographed this stunning sunset, I selected the camera's Cloudy WB preset. By deliberately 'mismatching' the WB setting in this way, I have further enhanced the image's warmth.

lighting is similar, but the underexposure less extreme. You need to ensure that the light source is directly behind the subject. The subject should then be slightly underexposed, while the light that surrounds picks out any texture on the edge of the subject.

Colour

The colour of light (its colour temperature) is determined by the temperature (in degrees Kelvin) of the source from which it was emitted. Most light is perceived as white by the eye, but recorded images are less forgiving. The processor of the D40 & D40x can adjust the white balance to compensate for different sources; however, while the automatic white balance function normally produces accurate results, it can neutralize appealing colour casts. To achieve the best result, you should think creatively. If you are shooting in NEF (RAW) you can alter the white balance during post-processing, but if you shoot JPEGs, you will

ICE PATTERN

A cool blue hue will create the feeling of coldness. On this occasion, I selected the Fluorescent WB preset to enhance the colour of this ice pattern.

need to get it right in-camera. The right white balance depends on your interpretation; typically, warm tones are enhanced by a setting intended to be accurate under cool lighting, such as cloudy or shade; while images with cool tones can be exaggerated by settings such as Fluorescent.

Image properties

Some technical properties of a digital image are a product of the way that digital cameras capture images. These are outlined here, along with steps that you take to limit their effect.

Dynamic range and clipping

The dynamic range is the range from brightest to darkest tone that can be captured in a single image. If tones within an image exceed this range, then either the highlights or the shadows, or in some instances both, will be rendered without detail or, in other words, clipped. Technically the dynamic range is the difference between the maximum signal that each photodiode can transmit (the brightest the pixel can be without being pure white) and the lowest value that it can transmit (the

Imaging artefacts

Imaging artefacts are flaws derived from the way the image is captured or the way it has been processed. These include a range of problems that are discussed below. These issues are usually exaggerated by shooting in JPEG format, because of the way in which JPEG files are compressed. Therefore, it is advisable to shoot in NEF (RAW) if you wish to maximize image quality. Don't let that put you off using JPEGs though, as most of the problems discussed below are only visible at high magnifications.

darkest the pixel can be without being pure black). This range is at its greatest at low ISO sensitivities. Even though the D40 & D40x have an impressive dynamic range throughout, whenever possible, it is best to use it at the lowest viable ISO rating. This also ensures that the roll-off (the graduation through the brighter tones to the extreme highlights) is as soft as possible.

SNOWDROPS
Where the sunlight is directly striking this group of snowdrops, it has exceeded the camera's dynamic range, clipping to pure white.

Chromatic aberration

Chromatic aberration is actually a property of the lens rather than the sensor itself. However, the fact that light either falls on a pixel or does not, coupled with the slight gap between the light-gathering micro lenses means that a lens's inability to bring the different colours of the spectrum into focus at one point – its chromatic aberration – is visible in close-up, often more than on film. This takes the form of a colour shift that is visible as a tiny border along the light side of a high-contrast transition. The colours are normally red and green, and although this can be processed out using photo editing software like Photoshop, it is best to use high-quality Nikkor lenses which employ lens technologies that minimize this flaw.

False colours, moiré and maze

The pattern or texture on a subject and the pattern in which the pixels are laid out on the sensor can clash to cause a digital sensor to register false colours, or an undulating effect known as moiré. If this is not carefully processed, then it can result in maze artefacts, which give moiré a jagged appearance. To minimize this effect the Nikon D40 & D40x, like most digital SLRs, employ a low-pass filter to blur incoming light. This blurs the image and almost entirely removes moiré and false colours. The camera's processor then utilizes a series of algorithms to restore the sharpness that the low-pass filter initially sacrifices. The result is a high-resolution image with little or no false colour or moiré, and certainly no evidence of maze artefacts.

Flare

When shooting towards a light source, there is an increased risk of flare. Flare is the result of non-image forming light reaching the digital sensor; normally caused by intense light, like the sun. It is created when light doesn't pass directly along its intended path and instead bounces back and forth between the internal lens elements before finally striking the camera's sensor. It can appear in many forms, but typically brightly fringed polygonal shapes (in a variety of sizes), in addition to bright streaks and a reduction in contrast. Although lens flare can be used creatively, it is normally undesirable and can often ruin a picture. Although many modern optics are designed with surface coatings to combat its effects, normally it is possible to eliminate flare by simply altering your position. A lens hood can also be attached to help limit stray light entering the camera, but be aware of vignetting. An alternative option is to try shielding the lens with a sheet of card or even your hand, being careful that your shield doesn't accidentally encroach into the frame.

Noise

Noise is the appearance of variations in signal transmitted by each pixel. Each photodiode senses how much light falls on it and transmits that as a digital value. However, because the quantities of light involved are small, gathered over a tiny area and a relatively short period of time, any slight variations are amplified. This can create a grainy appearance, particularly in flat tones, and even more so in flat, dark tones. Three variables affect noise: temperature, sensitivity and duration. Higher temperatures, sensitivities and longer durations all increase the level of noise. The noise performance of the Nikon D40 & D40x is excellent; even at high ISO ratings and long exposures, the camera will produce acceptable results. If you are using long exposures, you should employ the camera's noise-reduction function (page 83).

Aliasing and sharpening halos

Because an image is made up of individual pixels, their shape can sometimes become visible, causing an effect known as aliasing. This usually afflicts low-resolution images, causing diagonal or curved lines to appear jagged and is most visible at high-contrast transitions, such as the edge of a building. JPEG compression compounds this, so it is best to shoot in NEF (RAW) format. If you prefer JPEGs, select the highest quality and resolution.

Sharpening an image can cause aliasing, so sharpening of NEF (RAW) images is best left to post-processing, when it can be controlled with greater precision. JPEGs should be sharpened before compression, which will give a better result than sharpening the compressed image later. The default setting is best – too much sharpening can increase aliasing and introduce sharpening halos. Sharpening creates the illusion of sharpness by increasing the edge contrast; if taken too far, a 'halo' of unnatural contrast can appear around the edge.

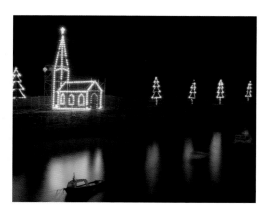

MOUSEHOLE, CORNWALL, UK
When I photographed the renowned Mousehole Christmas lights, I had to employ a lengthy 8sec exposure due to the limited available light. By employing the camera's noise-reduction facility, the effects of noise remain minimal.

Barrel and pincushion distortion

Barrel and pincushion distortion are both the result of lens design. Barrel distortion is when an image bows outwards at its edges; this is most noticeable when you are photographing a subject with straight lines that run along the edge of the frame, most common when using a wideangle lens. The opposite problem, which is pincushion distortion, occurs in some telephoto images and the image appears to bow inwards. Both of these problems can be corrected in Photoshop, but if possible it's best to avoid them in-camera. They occur most commonly in cheap zoom lenses, so avoid buying low-quality optics.

These two problems are more obvious at either end of the zoom range so you can try to lessen the effect by moving forwards and zooming out (to avoid pincushion distortion at full telephoto zoom) or moving backwards and zooming in (to avoid barrel distortion at the extreme wideangle).

⚠ Common errors

A bright speck in a constant position is not noise, but a 'stuck' or 'hot' pixel – a failed pixel on the sensor. This can be 'mapped' out if you return your camera to Nikon, but before returning your camera, make sure that the flaw is with the sensor rather than the LCD monitor by checking the image on computer.

Vignetting

Vignetting is the darkening of an image at its edges, when less light falls on these areas than the middle. It afflicts all lenses at their widest aperture, but if you stop the lens down slightly then the problem should be corrected.

Another source of vignetting is filters with thick mounts or lens hoods that obstruct light entering the lens. So, use filters with a thin mount or a lens hood specifically designed for the lens in use.

WELSH LAKE
Vignetting is a problem most commonly caused when two or more filters are stacked together. This obstructs the light entering the lens, darkening the corners of the frame. Its effect is clearly obvious in this photograph of a Welsh lake.

Using exposure compensation

I was photographing the fresh, spring foliage in local woodland when I spotted a hazel heavy with photogenic catkins. It was morning and the sun was still low in the sky, so I decided to photograph the catkins backlit to create a more visually interesting image. However, I anticipated that the tricky lighting conditions and light coloured background would fool the camera's metering into underexposure. To compensate for this, I set exposure compensation to +1 stop (page 48).

HAZEL CATKINS
Hazel is a common and widespread small tree or shrub, which is often coppiced. Photogenic male catkins and tiny red female flowers appear during late winter and early spring.

Settings
Manual (M) mode
Exposure compensation +1 stop
Manual focus

Creating a silhouette

Silhouettes are the most extreme form of backlighting. The subject is recorded as a simple, black shape without colour or detail. Almost any subject can work well recorded as an inky black shape, such as a tree, people, animals or buildings. However, the most visually striking results will normally be achieved by photographing bold, obvious subjects which will be immediately recognizable. The best time of day to shoot silhouettes is morning and evening when the sun is lower in the sky. I took this photograph of an avenue of trees, just as the sun was rising.

I used the support of a tripod and composed the image. I then took a spot meter reading (page 45) from a bright area of the sky and employed the resulting settings to take the photo. By intentionally exposing for the sky in this way, the trees were rendered underexposed, thus creating a perfect, black silhouette.

Spot metering from a bright area of the scene is a quick and effective way to ascertain the correct exposure to shoot a silhouette. However, if in doubt, bracket your exposure to guarantee a correctly exposed result.

SILHOUETTED TREES
I set my alarm early in the hope of a colourful sunrise. Although the sky wasn't spectacular, this avenue of trees created picture potential. To add warmth to the morning sky, I selected the Cloudy WB preset.

Settings
Manual (M) mode
Spot metering
WB set to 'Cloudy'

Foreground interest

To give scenic images depth and life, it is important to include some form of foreground interest. You can utilize practically anything just so long as it complements the main scene or subject, for example, a rocky outcrop, fallen tree or colourful flowerbed. Foreground interest will also give your image a natural 'entry point', leading the viewer's eye into the photograph.

I was photographing St Michael's Mount, one of Cornwall's best known landmarks, from the beach at Marazion. I knew the Mount would be the image's main focal point, but a rocky outcrop and the sandy beach created ideal foreground potential. The sunlight was fading fast, so I had to work quickly. I adopted a low viewpoint to help emphasize my foreground detail and decided that a vertical composition worked best. I selected a small aperture and focused at the hyperfocal point (page 115) to maximize depth of field.

ST MICHAEL'S MOUNT
Finding a beautiful sweeping vista to photograph isn't enough to guarantee a great image. If you wish to take more than a simple snap, you will need to create a strong composition overall. Often the key ingredient to doing this is to identify and include some form of foreground interest.

Settings
Manual (M) mode
Hyperfocal focusing
Polarizing filter

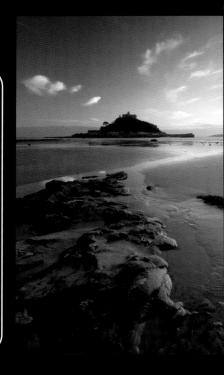

Subject off-centre

It was a chilly winter's evening on Dartmoor when I noticed the photographic potential of this weathered, windswept tree. The evening sunlight was soft and warm and the wispy cloud in the sky added further appeal. I selected a low viewpoint and a short focal length, so I could utilize the granite outcrops as foreground interest. I intentionally positioned the tree off centre to create a visually strong, interesting composition. This technique is known as the 'rule of thirds' (page 121). By placing key focal points and interest on one of the imaginary intersecting thirds, the photographer shifts more emphasis to the subject's surroundings – creating a more interesting picture overall. This photograph is aesthetically far more appealing than if I had positioned the tree centrally.

WINDSWEPT TREE
The low, evening sunlight gave this scene a warm glow. A low shooting angle and a wide 12mm focal length created an eye-catching result. A polarizing filter enhanced the clear blue sky.

Settings
Manual (M) mode
Rule of thirds
Polarizing filter

Combating camera shake

I watched this green-veined white butterfly land on a celandine flower. I guessed it wouldn't stay resting for long, so I had to work quickly. I knew I wouldn't be able to utilize the support of a tripod, due to the enhanced risk of disturbance. Therefore, I had to shoot handheld. I lay prone to get level with the insect and used my elbows to support my set-up. However, at high magnifications, the slightest movement appears greatly exaggerated and I was concerned about camera shake. To combat this, I decided to increase ISO sensitivity to 400 to allow a shutter speed sufficiently fast to freeze my movement. The camera's excellent sensor and processor meant that image quality remained high.

Settings
Manual (M) mode
ISO 400 rating
Manual focus

GREEN-VEINED WHITE
Butterflies are popular, but tricky subjects to photograph. They will react quickly to any sudden movements. Therefore, approach them slowly and with care, otherwise they'll soon fly away.

Manipulating depth of field

Whilst it is often desirable to record a subject in sharp focus throughout, the use of selective focusing, through manipulating a narrow depth of field, can often create a more visually striking image – especially when shooting close-ups. On this occasion, I deliberately selected a wide aperture of f/2.8 so that only my point of focus was recorded sharp. The flowers in the foreground and background are rendered in soft focus, helping draw the viewer's eye to my intended point. This creates a very pleasant effect, although pinpoint focusing is essential.

WOOD ANEMONES
Wood anemones are attractive woodland perennials, which often form large carpets of flowers – ideal for photography.

Settings
Aperture priority auto (A) mode
ISO 200 rating
Manual focus

Blurring motion

BREAKWATER
The late evening light cast the breakwater into inky silhouette, contrasting starkly with the blurred water. The rocky outcrop in the foreground gives the image depth and interest.

Settings
Neutral density filter
Noise reduction

Blurring the motion of moving water, using a long shutter speed, is a popular and well used technique. However, it is one that can prove very effective and photographers can have a lot of fun experimenting with the effect. When I took this photograph of a Cornish breakwater, I attached a neutral-density filter – designed specifically to reduce the amount of light entering the camera. The filter had a 'filter factor' equivalent to two stops of light, allowing me to set a lengthy shutter speed of eight seconds. This was sufficiently slow to reduce the rising tide to a pleasant, blurry mist – creating the impression of motion. When taking pictures using long exposures like this, a sturdy tripod is essential. I switched the camera's noise-reduction option on, to maximize image quality.

Achieving good saturation

This photograph of a row of beach huts relies on its colour, form and the simplicity of the composition for its impact. Once I had downloaded the NEF (RAW) file onto my computer, and began the post-processing sequence, I decided that the image would benefit if I 'tweaked' the colour settings slightly. Capturing the original in NEF (RAW) format, gave me the added flexibility to make minor adjustments to the white balance, saturation and hue settings using Nikon Capture NX (not supplied). This sophisticated software enabled me to enhance the image further, creating a more eye-catching result. The ability to fine-tune your images is the most compelling reason to shoot in NEF (RAW) format whenever possible.

BEACH HUTS
This row of colourful beach huts caught my eye one evening when I was photographing the seaside. I decided a low viewpoint worked best and intentionally tilted the camera at an angle to create an arty, visually interesting result.

Settings
Manual (M) mode
NEF (RAW) format
Nikon Capture NX software

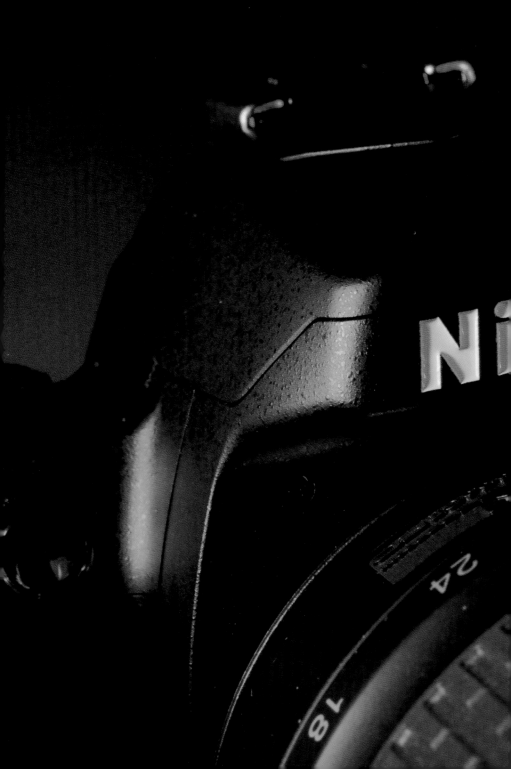

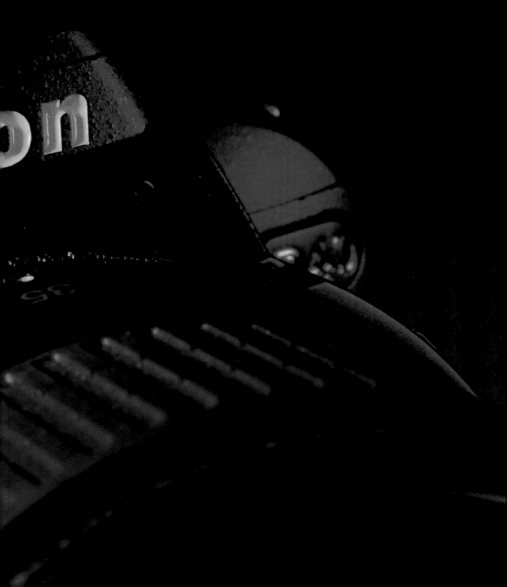

Chapter **4**

Flash and the Nikon D40 & D40

Although the science of flash photography is complex and can seem intimidating at times, the Nikon D40 & D40x simplify the processes and techniques involved. Therefore you can create impressive results and effects without having an in-depth technical understanding of flash. However, that isn't to say that a greater level of understanding will not help your flash photography; indeed, understanding how the Nikon flash range works, and knowing what options are available to D40 & D40x owners will only help you to create better images.

The Nikon D40 & D40x have a built-in flash unit, with a guide number of approximately 55/17 (ISO 200, ft/m) or 39/12 (ISO 100, ft/m – D40x only). When fired at full power in manual mode, this is extended to 59/18 (ISO 200, ft/m) or 42/13 (ISO 100, ft/m – D40x only). The flash synchronization speed (x-contact only) is up to 1/500sec (D40) or 1/200sec (D40x), although lower speeds can be selected. However, higher speeds can be chosen in conjunction with a high-speed synchronization-compatible (FP) speedlight that supports the Nikon Creative Lighting System (CLS).

Guide numbers

The guide number of a flash unit denotes its power, and can be used to calculate the relevant aperture or, more usefully, the distance that a flash can effectively cover. The number is normally given in feet or metres for a sensitivity rating equivalent to ISO 100 or 200. The guide number can be used in two equations:

f-stop = guide number/distance
distance = guide number/f-stop

For example, the guide number of the D40 & D40x built-in flash is 55/17 (ISO 200, ft/m). The effective distance that the flash can be used up to depends on the aperture set. If, for example, the aperture is set to f/4, the maximum distance at which the flash can be used effectively can be calculated as:

distance = 55(17)/4 = 13ft 7in or 4.25m

Lens compatibility

While the built-in speedlight can be used in conjunction with any Nikon CPU lens with a focal length of 18–300mm, it may be unable to light the entire frame if certain lenses are not used at or above the minimum ranges shown in the table below.

Lens	Zoom position	Min. range
AF-S DX ED 12–24mm f/4G	20mm	3.0m / 9ft 10in
	24mm	1.0m / 3ft 3in
AF-S ED 17–35mm f/2.8D	24mm	2.0m / 6ft 7in
	28mm	1.0m / 3ft 3in
	35mm	0.6m / 2ft 3in
AF-S DX ED 17–55mm f/2.8G	28mm	1.5m / 4ft 11in
	35mm	1.0m / 3ft 3in
	45–55mm	0.6m / 2ft 3in
AF ED 18–35mm f/3.5–4.5D	24mm	1.0m / 3ft 3in
	28–35mm	0.6m / 2ft 3in
AF-S DX ED 18–70mm f/3.5–4.5G	18mm	1.0m / 3ft 3in
	24–70mm	0.6m / 2ft 3in
AF 20–35mm f/2.8D	24mm	2.5m / 8ft 2in
	28mm	1.0m / 3ft 3in
	35mm	0.6m / 2ft 3in
AF-S VR ED 24–120mm f/3.5–5.6G	24mm	1.0m / 3ft 3in
	28–120mm	0.6m / 2ft 3in
AF-S ED 28–70mm f/2.8D	35mm	1.5m / 4ft 11in
	50–70mm	0.6m / 2ft 3in
AF-S VR ED 200–400mm f/4G	250mm	2.5m / 8ft 2in
	300–400mm	2.0m / 6ft 7in
AF-S DX ED 18–135mm f/3.5–5.6G	18mm	1.0m / 3ft 3in
	24–135mm	0.6m / 2ft 3in
AF-S DX VR ED 18–200mm f/3.5–5.6G	24mm	1.0m / 3ft 3in
	35–200mm	0.6m / 2ft 3in

Operating the built-in flash speedlight in i-TTL mode

i-TTL is a new flash technology introduced to work alongside Nikon's Creative Lighting System (CLS), which takes advantage of the enhanced communication capabilities of digital cameras and provides increased flash shooting functionality when used in conjunction with the D40 or D40x. In i-TTL flash mode, monitor pre-flashes are fired continually and exposure is less susceptible to the effects of ambient light than is the case with standard TTL flash. When used in conjunction with CPU-type lenses, the built-in speedlight operates in one of two i-TTL flash control modes: i-TTL balanced fill-in flash for DSLR and standard i-TTL flash for DSLR.

i-TTL balanced fill-in flash for DSLR

This mode is automatically selected unless the spot metering mode is in use. The speedlight emits a series of imperceptible pre-flashes immediately before the main flash is fired, which are reflected from all areas of the frame and are recognized by the 420-segment RGB sensor. These pre-flashes are analysed by the camera in conjunction with the information gathered from the matrix metering system and, if D- or G-type lenses are attached, then distance information and flash output are adjusted to give as natural a balance as possible between the main subject and the ambient background lighting.

Standard i-TTL flash for DSLR

When the D40 or D40x are set up so that i-TTL balanced fill-in flash doesn't operate (i.e. when spot metering is used), then standard i-TTL flash for DSLR automatically activates. In i-TTL flash for DSLR mode, the flash output is adjusted to ensure the main subject is correctly exposed, but background brightness isn't considered. This is recommended for use with exposure compensation, for shots in which the main subject is emphasized at the expense of background detail, or when using an SC-series 17, 28, or 29 sync cable. Standard i-TTL flash control is used with spot metering or when selected with the optional speedlight. i-TTL balanced fill-in flash for DSLR is used in all other cases.

Operating the built-in flash

Although the camera's built-in flash isn't as powerful or flexible as an external speedlight, it is still a useful tool. It can be used when natural light is inadequate, to add balanced fill-in flash when backlighting is excessive or to relieve ugly, dark shadows. Used in conjunction with flash exposure compensation, it is capable of producing some pleasing results.

The built-in flash will activate automatically in Auto, Portrait, Child, Close-up and Night portrait shooting modes when additional lighting is required to achieve a correctly exposed result in poor light. Alternatively, it can be manually activated in P, S, A and M modes. Note: the built-in flash cannot be used in Sports, Auto (flash off) or Landscape shooting modes.

Operating the flash in Auto, Portrait, Child, Close-up and Night portrait shooting mode

1) Rotate the mode dial to either Auto, Portrait, Child, Close-up or Night portrait shooting mode.

2) Select a flash mode. Press the shutter-release button halfway to pop up the flash. It will automatically begin charging and, when ready, the flash-ready indicator in the viewfinder display will light. Fully depress the shutter-release button to take the photograph.

Operating the flash in P, S, A or M modes

1) Rotate the mode dial to either P, S, A or M.

2) Manually activate the built-in speedlight by pressing the ⚡ button on the side of the pentaprism. It will automatically begin charging and, when ready, the flash-ready indicator in the viewfinder display will light. Select a flash mode.

3) Select a metering method, choosing matrix or centre-weighted to activate i-TTL balanced fill-flash. Standard i-TTL flash is activated when spot metering has been selected.

4) Fully depress the shutter-release button to take the photograph. If you wish to prevent the flash from firing, lower the flash.

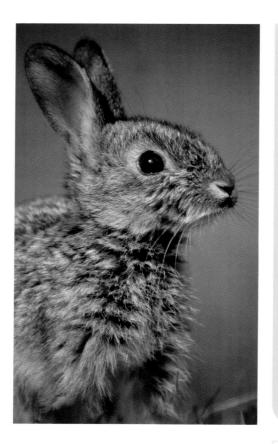

RABBIT
A camera's speedlight might lack the
strength, flexibility and creative control
of an external speedlight, but it can
prove useful in a range of shooting
situations. In this instance, I used a
small burst from the camera's pop-up
flash to add a catchlight to the rabbit's
eye – giving the image more life.

Flash exposure

Listed in the table below are the
shutter speeds that are available
when the built-in speedlight is
raised in the D40 & D40x's Digital
Vari-program exposure modes.

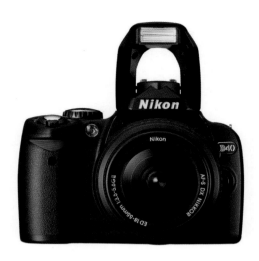

BUILT-IN FLASH
The Nikon D40 & D40x built-in flash
unit is versatile, useful and convenient.

| Shutter speeds available with built-in flash | |
Mode	Shutter speed
D40	
Auto, Portrait, Child, P, A	1/500–1/60sec
Close-up	1/500–1/125sec
Night portrait	1/500–1sec
S	1/500–30sec
M	1/500–30sec, bULb
D40x	
Auto, Portrait, Child, P, A	1/200–1/60sec
Close-up	1/200–1/125sec
Night portrait	1/200–1sec
S	1/200–30sec
M	1/200–30sec, bULb

Flash range

The range of any flash varies depending on the ISO sensitivity and aperture selected. The table below shows the flash range of the built-in speedlight when it is used at certain ISO and aperture combinations.

Aperture at ISO equivalent of				Range	
200	400	800	1600	ft	m
f/2	f/2.8	f/4	f/5.6	3ft 3in–24ft 7in	1.0–7.5
f/2.8	f/4	f/5.6	f/8	2ft 4in–17ft 9in	0.7–5.4
f/4	f/5.6	f/8	f/11	2ft–12ft 6in	0.6–3.8
f/5.6	f/8	f/11	f/16	2ft–8ft 10in	0.6–2.7
f/8	f/11	f/16	f/22	2ft–6ft 3in	0.6–1.9
f/11	f/16	f/22	f/32	2ft–4ft 7in	0.6–1.4
f/16	f/22	f/32	—	2ft–2ft 11in	0.6–0.9
f/22	f/32	—	—	2ft–2ft 4in	0.6–0.7

Flash modes

The duration of a flash burst is just milliseconds, so it must trigger when the shutter is fully open or the image will be partly unexposed. Every camera has a maximum shutter speed at which a flash burst will expose the full frame. This is known as its flash sync (also called the X-sync) speed.

The Nikon D40 has a maximum flash sync of 1/500sec, while the D40x has a flash sync of 1/200sec. The different flash sync modes allow you to change the way the flash unit operates depending on shooting conditions. Some flash sync modes are only available in certain exposure modes.

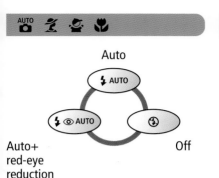

Auto

Auto+
red-eye
reduction

Off

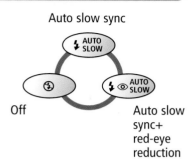

Auto slow sync

Off

Auto slow
sync+
red-eye
reduction

P, A

Fill-in flash

Red-eye
reduction

Rear
curtain+
slow sync

Slow sync+
red-eye reduction

Slow sync

S, M

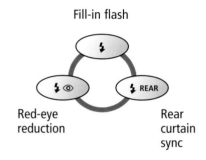

Fill-in flash

Red-eye
reduction

Rear
curtain
sync

Setting the flash mode

The flash mode can be set in two ways.

1) With built-in speedlight raised, press the 🗲 button and rotate the command dial to set the flash mode you require.

2) Alternatively, with the shooting information screen displayed, depress the **i** to adjust the settings.

Using the multi-selector, scroll to flash mode and press **OK**. Scroll up or down to select the flash mode – the displayed image to the left of the setting represents the effect of the parameter. Press **OK**. To take an image using the selected flash mode, proceed following the steps on page 143 for the built-in flash, or on page 151 for an external speedlight.

Fill-in flash

i-TTL balanced fill-flash for digital SLR. Flash output is adjusted for a natural balance between the main subject and the background.

Auto

When lighting is poor or the subject is backlit, flash will pop up automatically when the the shutter-release button is pressed halfway and fire when a photograph is taken.

Red-eye reduction

Red-eye is a problem caused by flash reflecting off the retina; with some animals it can be green-eye. This is a particular problem when the subject is looking directly into the lens and the flash is close to the optical axis. When red-eye reduction is selected, the AF-assist lamp lights prior to the main flash, contracting the pupils to minimize the effect.

Slow sync

One problem with flash is the limited distance that a burst can travel and the abrupt 'fall off' of light. In low light, this can cause backgrounds to be badly underexposed or even appear completely black. Choosing a slower shutter speed, combined with slow sync mode, will allow the sensor to expose the naturally lit areas for longer, creating a more even exposure over the entire scene.

Red-eye reduction with slow sync

This mode combines the red-eye reduction feature with a slow flash sync. This is particularly useful for countering red eye in portrait shots at night, in which you want the background to be properly exposed.

Rear-curtain sync

Selecting rear-curtain sync mode triggers the flash unit just before the shutter closes – rather than at the beginning of the sequence as occurs normally. The purpose for this mode is that, when photographing moving subjects, you generally want any 'trail' to appear behind the subject rather than in front of it. Otherwise, the effect can appear unnatural.

Flash exposure compensation

Flash exposure compensation is available in P, S, A or M modes only. It works in a similar way to the camera's exposure compensation feature (page 48), allowing you to increase or decrease the flash output from the level automatically selected by the camera. This gives you greater control over the appearance of the final image. Increasing the exposure by selecting positive (+) compensation will increase the illumination from the flash unit and can be employed when the main subject is much darker than the background. Negative (–) exposure compensation will reduce power output and can be used, amongst other things, for balancing the tonal range between a bright subject and a dark background. By employing flash exposure compensation, you can fine-tune flash exposures to achieve a more natural appearance and manipulate the flash exposure for creative effect. The flash compensation value can be set between –3Ev (darker) and +1Ev (brighter) in increments of 1/3Ev.

Flash exposure compensation can be set in two ways.

1) Press the 🔲 and 🔘 buttons and rotate the command dial to set the flash compensation value you require, displayed in the shooting information display and viewfinder (P, S, A and M modes only).

1) Alternatively, with the shooting information screen displayed, depress the **i** to adjust camera settings. Using the multi-selector, scroll to Flash level and press OK. Scroll up or down to set the compensation value – the image to the left of the setting will lighten or darken to represent the effect of the parameter. Press OK.

2) Once flash compensation has been applied, a ⚡ will be displayed in the viewfinder to indicate a positive or negative compensation has been programmed. Also, the current value for flash compensation is shown in the shooting information display.

3) To take an image with flash compensation, raise the built-in flash unit or attach an external speedlight, and then proceed following the steps on page 143 for using the built-in flash, or on page 151 for using an external speedlight. Flash exposure compensation is not reset when the camera is turned off. To restore normal flash settings, set flash exposure compensation to ±0.

Note
Flash compensation is also available in conjunction with SB-400, SB-800, SB-600 and SU-800 flash units.

The inverse square law

When using flash, it is useful to keep in mind the limitations imposed by the inverse square law. Simply put, it means that at a constant output, the illuminating power of the flash will be the inverse square of the distance. This means that as you double the distance between flash and the subject, the illumination is quartered. Obviously a modern flash will try to compensate for this, but it is limited in the extent that it can do so – this dramatic fall-off is the reason why it is a good idea to buy the most powerful flash you can afford.

Tips
Flash exposure compensation is a good way of exerting a creative influence on your images. Generally the more the flash exposure dominates the ambient exposure, the more artificial the lighting effect is. For subtle effects, employ a negative compensation and for more dramatic effects, use positive compensation.

Flash level can also be adjusted via custom setting 08.

Note
The D40's shutter will synchronize with an external flash at speeds of 1/500sec or slower – and the D40x at speeds of 1/200sec and slower. i-TTL flash control can be used at ISO sensitivities between 200 and 1600. Higher values may not produce the desired results at some ranges or apertures. If the flash-ready indicator blinks for about three seconds after a photograph is taken, the flash has fired at full power and the photograph may be underexposed.

Using external speedlights

Whilst the D40 & D40x's integral speedlight will often prove useful, due to its fixed position, it lacks the flexibility and creative possibilities of an external dedicated unit.

However, Nikon produces a wide range of powerful, sophisticated speedlights that will prove a good addition to your kit bag.

Mounting an external speedlight

1) First remove the camera's accessory shoe cover. Then, making sure that the camera and speedlight are switched off and the built-in flash is closed, slide the foot of the speedlight into the hotshoe.

2) Rotate the mounting foot lock lever, located at the base of the speedlight, in order to extend the locking pin.

3) Switch the speedlight and the camera on.

⚠ Common errors
If the speedlight's foot will not slide smoothly into the hotshoe, do not force it. It is likely that the locking pin is extended, so rotate the locking wheel to retract it and then try again.

Flash units are very heavy on battery usage. Therefore, it is important that you should always carry replacement batteries in your camera bag.

DOOR HANDLE
One of the advantages of using an external speedlight is that it can be used off-camera – via a flash cord – and carefully positioned for creative effect. By positioning the speedlight left of the camera – as opposed to overhead – the flash burst has created a well-defined shadow, which has added depth and interest to this shot of a brightly painted door.

Using bounce flash

When a speedlight has an adjustable head, you can bounce flash to soften its effects or position the shadows out of sight. Consider the colour of the surface that you are bouncing the flash off – the reflected light will be of this colour. White walls or ceilings are generally best.

1) Select the exposure mode.

2) Tilt and/or swivel the flash head accordingly.

3) Semi-depress the shutter-release button to take a meter reading.

4) Apply any alterations to the exposure variables.

5) When the ready light has appeared on the speedlight, fully depress the shutter-release button to take the photograph.

INTERIOR
When shooting building interiors, bouncing your flash burst off the ceiling or white walls will help create pleasant, even illumination.

SB-400

The most recent addition to the Nikon speedlight range – launched to coincide with the launch of the D40. This flash unit provides i-TTL flash operation in a compact, lightweight body and at an affordable price. Its flash head can be tilted in four steps and it has a flash shooting distance range from 2ft to 65ft (0.6–20m) – depending on the ISO setting. Slow sync, red-eye reduction and other flash modes can be set on the camera body. Although the SB-400 is aimed at entry-level digital SLR users, it can also be utilized by Nikon D2 series digital camera users as a handy, compact flash unit.

Guide number
30/98.4 (ISO 200, m/ft), 21/69 (ISO 100, m/ft)

Tilt/Swivel
Flash head tilts up to 90° with click-stops at 0°, 60°, 75°, 90°

Recycling time
3.9 seconds with AA batteries

Approximate number of flashes
140 at full output

Dimensions (w x h x d)
68 x 123.5 x 90mm

Weight
127g (4.5oz)

Included accessories
SS-400 soft case

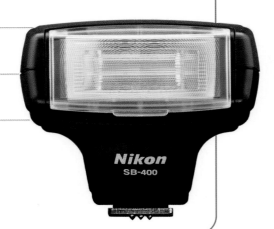

SB-600

While the SB-600 offers slightly less versatility than the SB-800, it is fully compatible with the Creative Lighting System and Advanced Wireless Technology. Featuring Nikon's latest i-TTL monitor pre-flash metering technology, the SB-600 is a powerful main flash for general photography. It also offers fully automatic exposure control when used in groups with other SB-600 units, controlled either by a master SB-800 or the commander mode of the D40 & D40x. The SB-600 is packed with practical functions to meet the lighting needs of the most creative photographer.

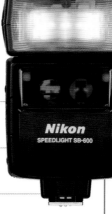

Guide number
GN 30 (m/ISO 100)

Flash coverage (lens focal length range)
24–85mm

Tilt/Swivel
Yes

Recycling time
3.5 seconds with AA batteries

Approximate number of flashes
200 at full output

Dimensions (w x h x d)
68 x 123.5 x 90mm

Weight
300g (without batteries)

Included accessories
AS-19 speedlight stand and SS-600 soft case

SB-800

The SB-800 is fully compatible with the full range of functions on the D40 & D40x. It forms the cornerstone of Nikon's Creative Lighting System, supporting the latest technology and offering a great deal of photographic versatility.

Guide number
GN 38/53 (m/ISO 100/200 at 35mm)

Flash coverage (lens focal length range)
24–105mm – 17 and 14mm with built-in adaptor, 14mm with SW-10H diffusion dome

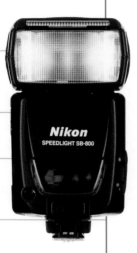

Tilt/Swivel
Yes

Recycling time
2.7 seconds with quick recycle pack, 6 seconds with AA batteries

Approximate number of flashes
150 at full output

Dimensions (w x h x d)
70.6 x 127.4 x 91.7mm

Weight
350g (without batteries)

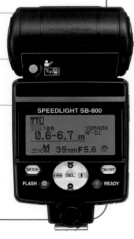

Included accessories
Quick recycle battery pack SD-800 (for one AA-size battery), diffusion dome SW-10H, speedlight stand AS-19, coloured filter set SJ-800 (FL-G1 and TN-A1) and SS-800 soft case

SB-R200

Compact, but powerful speedlight component of the Nikon Wireless Close-up Speedlight system. It is designed exclusively for remote use, so cannot be attached to the camera's hotshoe. Attached to a Nikkor lens, the unit can be triggered via theSU-800 or SB-800. Flexible output and simple analogue dials make manual control simple.

SU-800

Manage your entire Creative Lighting System of multiple flash units through the large, easy to use LCD panel on the SU-800. It attaches to the camera's hotshoe, removing the need for cables and separate flash meters to enable accurate automatic exposures in any lighting conditions. The SU-800 can control any number of i-TTL Creative Lighting System speedlights like the SB-800 or SB-600, or the dedicated SB-R200 remote speedlights for close-up photography. It has a range of up to 13ft (4m) when used with the SB-R200 and up to 66ft (20m) with other speedlights.

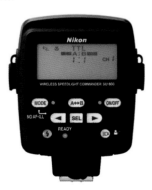

SB-R1C1 remote kit

Unique wireless speedlight system kit for fully automatic macro flash photography. The kit comprises two SB-R200 remote units attached to the lens and an SU-800 commander unit attached to the camera's i-TTL metering system. All exposure and triggering communication is carried out using infrared wireless communication. The kit includes adaptors for frontal lighting, filters and 52mm, 62mm, 67mm, 72mm and 77mm adaptor rings. Additional SB-R200 units or SB-800 and SB-600 units can also be controlled by the SU-800 to offer the ultimate Creative Lighting System flexibility either indoors or in the field. This kit is available without the SU-800 commander unit (SB-R1), as the built-in speedlight on the D40 & D40x can be used as the commander to trigger the set-up.

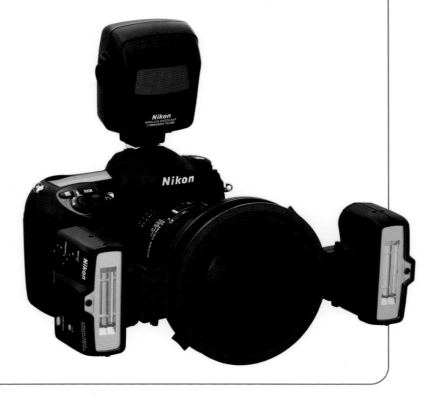

Flash accessories

Nikon has created a range of flash accessories for use with its dedicated speedlights. These accessories increase the flexibility of the Nikon D40 & D40x when used with external flashes, as they allow the external speedlights to be used away from the axis of the lens, thereby negating problems such as red eye and flat shadow. Some accessories also enable the use of multiple speedlights for advanced flash photography.

SJ-1 COLOUR FILTER SYSTEM
Useful for adding either subtle or dramatic colouring effects to the light from a flash unit.

SC-28 TTL cord
A 1.5m coiled TTL multi-flash sync cord that can be easily clicked onto the camera and the external flash for off-camera operation.

SJ-1
Colour filter system for the SB-800 that easily attaches without glue, Velcro or tape. The system includes fluorescent and tungsten for white balancing, and red and blue for creative effect.

SC-29TTL cord
Similar to the SC-28, this TTL multi-flash sync cord can be easily clicked onto the camera and the external flash for off-camera operation, but it also includes a switchable AF illuminator.

SD-800
The SD-800 is a quick-recycle battery pack that can be attached to the SB-800 speedlight to boost recycle time to 2.7sec. It takes one AA size battery and is supplied with the flash.

SD-800 QUICK-RECYCLE PACK
Attaches to the SB-800 speedlight to boost recycle time to 2.7sec.

Flash diffusers

Flash diffusers are inexpensive units that slide over the flash head to soften the output of the flash. Because the camera's i-TTL metering system meters light from an imperceptible pre-flash, the diffuser is taken into account and you need not make any adjustments other than remembering that your flash unit will effectively be weaker and therefore will not reach as far. The Nikon SB-800 is supplied with the SW-10H diffusion dome, but the Sto-fen Omnibounce is one of the most popular diffusers made by an independent manufacturers.

Flash extenders

Nikon does not produce flash extenders, but they are available from third-party manufacturers. Designed for use with longer focal lengths, a flash extender utilizes mirrors or lenses to concentrate the light from your flash, making it go further. This makes them popular with nature and sports photographers. As with flash diffusers, the appropriate exposure adjustments will be made by the camera's metering system.

Off-camera flash arms

Although flash can provide very natural-looking lighting, especially when diffused, it can also create hard, ugly shadow. Simply through altering the position and angle of the flash unit, it is possible to reduce or exaggerate shade. To minimize shadow – by casting it down and below the subject – the flash is best mounted above and directly behind the optical axis. However, this can create a very flat-looking light and it is normally more flattering to position the flash to the side of the lens. By doing this, shadows are cast in one direction, creating more depth and life. On-camera flash is severely limited when you require this type of creative control over the direction and effect of artificial light. To overcome these limitations, mount your flash off-camera instead, using a purpose-made flash arm or bracket. Flash arms are produced by manufacturers such as Wimberley, Novoflex and Stroboframe. Designs and flexibility vary depending on the make and model.

Note

When selecting a flash accessory, bear in mind that a number of slightly different models are normally available for different flash units. Make sure that you buy the correct one to fit your speedlight.

Chapter **5**

Close-up with Nikon

More often than not, the natural textures, structure and detail of the world go by largely unnoticed, but thanks to a few relatively inexpensive accessories, photographers are able to explore and capture this fascinating miniature world.

Although macro photography can be a challenging discipline, the results are worthwhile. However, before moving in too close, there are three key areas to consider: depth of field, image sharpness and lighting. When shooting at such close range, depth of field is dramatically reduced, and even the smallest aperture will result in just millimetres of acceptable focus – making the camera's playback facility an essential aid (page 59).

When depth of field is limited, pinpoint focusing is crucial. Working at close range, the usefulness of autofocus is greatly reduced and can actually restrict your creativity. The simple solution is to switch the camera to manual focus, select your point of focus carefully, and use a tripod together with the camera's self-timer (page 51) to minimize shake.

The final obstacle, limited light, is largely due to the use of small apertures, selected in an attempt

to achieve sufficient depth of field. Consequently, you will often be working with slow shutter speeds and any movement, either of the camera or the subject, will appear greatly magnified. In order to combat this problem, a higher ISO sensitivity (page 82) can be selected or electronic flash can be used to facilitate a faster shutter speed to prevent blur.

Working distance

Working distance is one of the crucial factors involved in the pursuit of close-up images. Because the CCD sensor of the Nikon D40 measures 23.7 x 15.6mm and that of the D40x measures 23.6 x 15.8mm – smaller than a 35mm film frame – the focal length of the lens attached will appear to be multiplied by a factor of 1.5. As a result, the camera is able to obtain close-up images using shorter focal length lenses than those needed for traditional film models. This is advantageous when photographing the natural world as the greater working distance makes it less likely you will disturb the subject.

COMMON BLUE BUTTERFLY
The cropped-type image sensors of the
D40 & D40x magnify the focal length
of the lens by a factor of 1.5. This
creates a larger working distance, so
it is easier to approach timid wildlife.

LARGE RED DAMSELFLY
A high reproduction ratio is required to photograph small insects. Either a dedicated macro lens or close-up attachment will be required.

Reproduction ratio

Reproduction ratio is a term given to the relationship between the size of your subject in real life, and the size it is recorded on the sensor. A reproduction ratio of 1:4 means that the subject will appear one quarter of its actual size on the sensor image. This is determined by the distance between the sensor and the subject, together with the focus of the lens. This is also referred to as subject magnification; a subject that appears on the sensor at lifesize is said to have a 1x magnification.

Close-up attachment lenses

Best combined with short, fixed-focal length (prime) lenses, close-up attachment lenses – also known as supplementary close-up lenses – screw onto the front of your lens like a filter. They work on the principle of placing a magnifying lens element in front of the camera lens to increase the size of the image projection. The magnification of these screw-in lenses is commonly measured in dioptres.

⚠ Common errors

When referring to reproduction ratios and magnification factors, it is the size of the subject in relation to the size of the image on the sensor that is being discussed. It is not the size of the image in the final print that is in question; this is why macro images often seem much larger than their stated reproduction ratio or magnification factor. For example an insect captured at a reproduction ratio of 1:1 or a magnification factor of 1x will appear as lifesize on the sensor, but when the image is enlarged for printing it will appear enormous.

EMERGING LEAF
One of the few disadvantages of using a close-up dioptre is that you need to get quite near to your subject to fill the frame. However, this doesn't create a problem when photographing static subjects like flowers and plants.

Two or more close-up attachments can be combined together; however, the more glass you put in front of the lens, the lower the quality of the picture. Although there is a slight reduction in image quality, these attachments are simple to use, excellent value for money and a good introduction to the world of macro photography. They do not reduce the amount of light reaching the lens. Therefore, they require no extra exposure calculations and are easy to use handheld.

There are seven different close-up attachment lenses available from Nikon. These are No. 0, 1, 2, 3T, 4T, 5T and 6T. They have different magnification values (dioptres) and fit two different thread sizes, namely the 52mm (No. 0, 1, 2, 3T and 4T) and 62mm (5T and 6T) sizes. Each attachment lens is treated with Nikon integrated coating for improved image contrast and to reduce the problem of flare.

Extension rings

Extension rings (also known as extension tubes) fit between the lens and the camera body and can be used singly or in combination to produce different reproduction ratios. This ratio can be calculated by dividing the extension by the focal length of the lens. A 25mm extension ring used in combination with a 50mm lens will provide a 1:2 half lifesize reproduction. This is only a rough guide and obviously depends on the close-focusing capabilities of the lens to start with.

Nikon produces four extension rings: the PK-11A, PK-12, PK-13 and PN-11, which offer 8mm, 14mm, 27.5mm and 52.5mm of extension, respectively. Owing to the high level of extension of the PN-11, it is designed with a tripod collar lock. The attachments work by physically extending the lens from the lens mount, away from the image sensor, decreasing the minimum focusing distance and therefore increasing the magnification of the image. They are lightweight and compact, making them a convenient and popular macro accessory. The drawback of using the rings is the loss of some of the camera's automatic features. For instance, focusing with any of the rings must be done manually, the only exposure mode available is manual, and the only metering options available are centre-weighted and spot. The benefit, however, is that they include no glass elements, so image quality is not degraded.

MARSH ORCHID
Extension rings are also a handy accessory for reducing the minimum focusing distance of longer focal lengths, so they can be utilized to photograph large flowers like this orchid.

Bellows

Bellows work using a similar principle to extension tubes by increasing the physical distance between lens and sensor, but the concertina design allows for more precise control over the reproduction ratio and resultant magnification. Despite their old-fashioned look, they are one of the best ultra close-up accessories available. However, they are pricey and, owing to their size and weight, best used in a studio environment. The main benefit of these attachments is that image quality remains unaffected: no extra glass between the lens and the subject means sharpness is not compromised. However, the level of light reaching the sensor is reduced and the exposure will need to reflect this. Nikon's PB-6 bellows permit extension from 48mm to 208mm for reproduction ratios up to 11x. German manufacturer Novoflex also produces an automatic bellows.

Reversing rings/adaptors

Ideal for those on a restricted budget, a reversing ring will allow you to mount your lens on the camera back to front and, as a result, focus much closer to your subject. The main drawback with this system is that in some cases the metering and automatic aperture stop-down facilities are lost once the lens is reversed – check the instructions before purchasing.

Tip
Judging the level of depth of field required to photograph any given subject can be a huge challenge. Remember to utilize the camera's playback facility, using the playback zoom to closely scrutinize image quality and check which areas of the image are acceptably sharp. If necessary, adjust the aperture and shoot again.

COLANDER
Attach a close-up accessory to your camera to transform the look of everyday, household objects. Even mundane subjects can look striking and abstract – like this metal colander.

Macro flash

Traditional flashguns can prove too powerful for close-up photography, and will not produce subtle, natural-looking results. Consequently, macro photographers often favour one of two options: macro flash or twin flash. The first of these is designed with two built-in flash modules that fit around the lens barrel, providing even, shadowless light on the subject. Nikon has designed the SB29s specifically for this purpose. Ultimately, for more advanced close-up photographers, a speedlight or twin flash unit, such as Nikon's SB-R1C1, may be the best option. This unique wireless speedlight system kit is designed with two SB-R200 remote units attached to

the lens and an SU-800 commander unit attached to the camera's i-TTL metering system. All exposure and triggering communication is carried out using infrared wireless communication. By using two separate flash heads, it is possible to aim them individually to offer directional lighting. The R1C1 provides an alternative to the characteristically 'flat' light of macro flash.

NIKON SB29S
The Nikon SB29s is designed to produce even, shadowless light to illuminate close-up subjects.

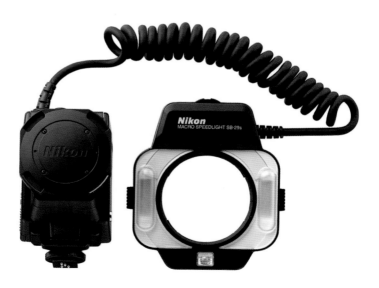

FUNGI
In situations where the natural light is
insufficient, it will need to be
supplemented using a burst of flash.

Macro lenses

The word 'macro' is commonly misused; technically a reproduction ratio of 1:1, or a magnification of 1x (lifesize) or greater, can be classed as macro, but the word has come to describe close-up work in general. While many zoom lenses boast a 'macro' setting, in reality the most likely reproduction ratio obtained using this type of setting is 1:4 (quarter lifesize). As you begin to take close-up photography more seriously, a dedicated macro lens – optimized for close focusing – is by far the best choice, offering superior quality at short focusing distances. Nikon currently produces five AF micro lenses which are optimized for close-up work and offer a 1:1 maximum

reproduction ratio: 60mm f/2.8D, 105mm f/2.8, 105mm f/2.8 VR IF-ED, 200mm f/4 IF-ED and 70–180mm f/4–5.6 ED. As you might expect, being a specialized lens, macro lenses are costly. However, Nikon's range of micro optics are each capable of focusing to infinity, making them suitable for general photography as well as close-up work.

The most recent addition to Nikon's range of micro lenses is the 105mm f/2.8 VR IF-ED. This is the world's first macro lens with vibration-reduction technology. Any camera movement is greatly exaggerated in close-up and can affect image sharpness. This macro lens incorporates Nikon's

Tips
Nikon's 200mm micro lens is a favourite amongst wildlife photographers. Its long focal length makes it easier to isolate subjects from their surroundings. It also allows you to remain further away from your subject, making it ideal for shooting creatures that might otherwise be disturbed, as well as preventing your shadow from falling over the object.

AF-S VR NIKON 105MM F/2.8 IF ED
Boasting vibration reduction technology, the Nikon AF-S VR 105mm micro lens is ideally suited to shooting handheld at shutter speeds up to four stops slower than would otherwise be possible.

A specific macro lens is one of the best tools for capturing high quality close-ups. It offers a great degree of flexibility as well as high optical quality.

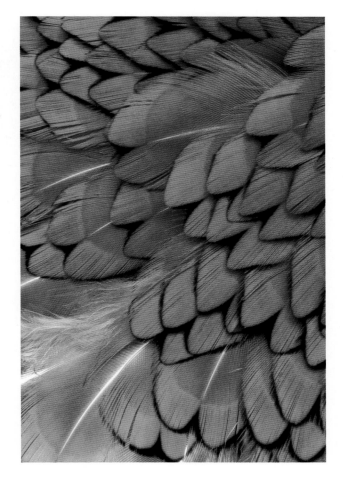

second-generation vibration reduction system (VR II), allowing photographers to capture sharp images at shutter speeds up to four stops slower than would otherwise be possible. The purpose of this is to make high-quality handheld close-up photography easier to achieve. The lens also boasts a silent wave motor (SWM) and internal focusing (IF) to ensure quiet autofocusing with quick and convenient switching between autofocus and manual operation. Optical performance is enhanced by an extra-low dispersion (ED) glass element that minimizes chromatic aberration.

Chapter **6**

Useful lenses

While the sensor plays the most significant part in determining the quality of the final image, the lens is also vitally important. Having invested in a quality Nikon digital SLR body, you do not want to compromise picture quality by using low-quality optics.

DX lens design

In film photography, light falling on the film is recorded accurately across the frame irrespective of the angle of incidence. The photosensor used in a digital camera, however, is a microchip with photodiodes laid out at regular intervals on a grid. The photodiodes sit in depressions and light can only reach them effectively if it comes through the lens from straight ahead. This means that if a 35mm film format lens is attached to a digital camera body, insufficient light at the edges of the CCD can result in a loss of image quality. The wider the angle of view of the lens, the worse the problem becomes. So Nikon began producing telecentric DX lenses, designed to ensure that light falls on the CCD as close to 90° as possible, thereby maximizing image quality.

The D40 & D40x employ the famous Nikon F-mount for attaching lenses. In theory, this means it can be used in conjunction with any Nikon lens made since 1959. However, some lenses might need special alterations before they can be used with the camera. For a list of current lenses, see pages 186–189.

Whilst the D40 & D40x boast a huge range of useful features, Nikon has had to make one or two compromises to market them at low prices. One of the cutbacks is that it does not have an internal focus drive motor. Instead it only has CPU contacts. Consequently, the D40 & D40x are only able to focus automatically with AF-S and AF-I type lenses – constructed with built-in motors. Therefore, if you wish to own lenses boasting full compatibility, this should be considered before purchase.

Nikon is renowned for its high-quality optics and boasts one of the most extensive lens systems of any manufacturer, ranging from the extreme wideangle DX 10.5mm AF-D f/2.8 fisheye to the reach of the AF-S 600mm f/4 telephoto.

It would be impossible to discuss all the different lenses in detail. Instead, this chapter will explain the characteristics of the modern Nikon range and identify some of the most useful lens types available to D40 & D40x owners.

Modern lens technology

Nikon incorporates many different technologies in its lenses to improve performance in a number of respects, such as optical quality, focusing and handling. The following table lists the main features.

AI-S – **Aperture indexing shutter meter coupling**	The AI-S design introduced a standardized aperture stop-down function, which is essential to achieving reliable and accurate shutter speeds in shutter-priority and program exposure modes.
ASP – **Aspherical lens elements**	Aspherical lenses are more effective at focusing the different wavelengths of light at a single point, minimizing the problem of chromatic aberration. **Main benefit** Minimizes chromatic aberration.
CRC – **Close-range correction system**	CRC lenses use a 'floating element' design that allows each element to move independently to achieve focus. **Main benefit** Improves quality at close focusing distances and increases the focus range in wideangle, fisheye, micro and some medium telephoto lenses.
D – **Distance information**	D-type and the new G-type Nikon lenses relay subject-to-camera distance information to the camera for use with 3D matrix metering exposure calculations. **Main benefit** Improves accuracy of TTL readings.
DC – **Defocus-image control**	Defocus-image control lenses are specialist lenses that are particularly useful for portrait photographers. DC technology allows the photographer to control the degree of spherical aberration in the foreground or background by moving a rotating ring. **Main benefit** An out-of-focus blur can be created that is ideal for portraiture.

ED – **Extra-low** **dispersion** **glass**	ED glass minimizes chromatic aberration, a type of image and colour dispersion that occurs when light rays of varying length pass through optical glass. **Main benefit** Improves sharpness and colour rendition.
G – **G-type lenses**	Because the majority of Nikon DSLR cameras are designed with a sub-command dial that controls aperture selection, Nikon launched the G-type lens that made the aperture ring traditionally found on the lens barrel no longer necessary. They also provide distance information for the 3D colour matrix metering system. **Main benefit** Reduced size and improved TTL metering.
IF – **Internal** **focusing**	Internal focusing allows a lens to focus without changing its size. All internal optical movement is limited to the interior of the lens barrel, which is non-extending. **Main benefit** Produces a lens that is more compact and lightweight in construction, particularly in long telephoto lenses. Also makes filter use, particularly polarizers, easier.
M/A – **Manual/auto** **mode**	Manual/auto mode allows almost instant switching from autofocus to manual operation, regardless of AF mode. **Main benefit** Reduces time lag when switching between auto and manual focus modes.
N – **Nano-crystal** **coating**	Nano-crystal coating is an ultra-thin anti-reflective coating that uses layers of extra-low refractive index coating to reduce reflections from internal lens elements and minimize ghosting and flare. **Main benefit** Ensures finely clear images.

RF – **Rear focusing**	With rear-focusing lenses, all the lens elements are divided into specific groups with only the rear lens group moving to attain focus. **Main benefit** Quicker and smoother autofocus operation.
S-ED – **Super-** **extra-low** **dispersion glass**	Super-extra-low dispersion glass minimizes chromatic aberration and other optical defects to an even greater extent than standard extra-low dispersion elements. **Main benefit** Increased image clarity.
SIC – **Super** **integrated** **coating**	Especially effective in lenses with a high number of elements, SIC is a multilayer coating that minimizes reflection in the wider wavelength range. **Main benefit** Reduces ghost flare to a negligible level.
SWM – **Silent wave** **motor**	Nikon's silent wave technology is used to convert 'travelling waves' into rotational energy for focusing. **Main benefit** This enables accurate and quiet autofocus operation at high speed.
VR – **Vibration** **reduction**	Vibration reduction lenses utilize internal sensors that detect camera shake and motors that automatically adjust the lens elements to minimize blur. **Main benefit** This technology reduces the occurrence of blur in images caused by camera shake, and allows handholding of the camera at shutter speeds slower than with a conventional lens.

Focal length and angle of view

The amount of a scene that is visible in the frame depends on the angle of view of the lens attached and also the distance between the focal plane and the subject. Lenses with a short focal length have a wide angle of view, while those with a long focal length have a narrow angle of view. At any given distance, the amount of the scene included (the field of view) will increase as the angle of view of the lens increases (as its focal length decreases). Conversely, as the focal length increases, the angle of view decreases and the amount of the scene included in the frame decreases. Using a longer focal length lens will cause the subject to appear larger within the frame than using a shorter focal length lens from the same distance. In fact the relationship is geometric; assuming the same subject-to-camera distance, a doubling of the focal length will cause the size of a subject within the frame to double. Alternatively, keeping the focal length the same but halving the subject-to-camera distance will also cause the subject's magnification within the frame to double. The following sequence shows a series of common focal lengths being used from one position and illustrates the effect that different focal lengths have on the field of view.

Focal length magnification factor

As mentioned previously, the size of the CCD used in all current Nikon digital SLRs is smaller than a 35mm film frame. Therefore, the focal length of the lens attached to your D40 or D40x is effectively increased by a factor of 1.5. For example, a 200mm lens on a Nikon digital camera will give an angle of view equivalent to a 300mm lens on a 35mm film camera. As a result, when selecting lenses it is important to remember how this effective increase will alter the perspective of your composition.

10mm

20mm

35mm

50mm

70mm

100mm

200mm

300mm

Perspective

Perspective is determined by the camera-to-subject distance and relates to the size and depth of subjects within the image space. Look at this series of images and you will note that, although the size of the principal subject remains the same, its relationship to the surroundings alters considerably.

A common misconception is that perspective is determined by the focal length of the lens. This isn't so; it is actually the camera-to-subject distance that determines perspective. Moving further away will compress the appearance of foreground-to-background space (between given points) while moving closer will exaggerate the foreground-to-background distance between certain elements. This sequence shows that the subject has been kept the same size by using different focal lengths (wideangles close to and telephotos further away). Alter your distance to the subject to create dramatically different effects, and select the focal length to maintain control over the size of the subject within the frame. Owing to the D40 & D40x's cropped sensors, you may need to use lenses from further away – in order to maintain the field of view – which will foreshorten perspective. The main problem with this is the loss of the characteristic appearance of wideangle shots.

18mm

35mm

70mm

100mm

150mm

Wideangle lenses

Wideangle lenses are those that offer a wider angle of view than standard lenses. This can be used to include a large field of view within the frame or to show a subject in relation to its environment.

Wideangle lenses provide the appearance of a large depth of field making them a good choice for images that need to be sharp from front to back. Because of the size of the CCD, and the resultant effect on the appearance of a particular focal length, you will find that wideangle lenses provide a less dramatic effect than on 35mm film. To counter this, Nikon has developed a new breed of super-wideangle lenses, such as the AF-S DX 12–24mm, specifically for its cropped-sensor DSLRs. This lens gives a field of view equivalent to that of an 18–36mm lens on a 35mm SLR offering a dramatic wideangle option for the Nikon user.

Standard lenses

Only a few years ago, practically every new SLR was bundled with a 'standard' 50mm lens. This focal length was standardized because on a 35mm film SLR, 50mm offers an angle of view equivalent to our own eyesight. The closest approximation for the Nikon D40 & D40x is around 35mm. This kind of focal length is particularly useful for 'straight' photography, where you wish to represent a subject as it appears. Zoom lenses that include the standard focal length within their range are often referred to as standard zooms.

Telephoto lenses

Telephoto lenses provide a narrow angle of view. Due to the distance that they are normally used from the subject, the perspective is compressed and this means that shorter telephoto lenses can be used to create pleasing portrait images with normal-looking features. Using longer telephoto lenses enables snappers to remain further away from the subject that they are photographing which is useful in a wide variety of shooting situations including wildlife and sports photography, where you can't easily get close to the action. Telephoto lenses are relatively heavy and their high degree of magnification will exaggerate any undue movement, so it is often advisable to use them in conjunction with a camera support – like a monopod or tripod – in order to minimize camera shake. The depth of field provided by a telephoto lens is limited, which can be very useful if you want to isolate the subject in front of or behind a flattering out-of-focus wash of colour. Because of the cropped sensors of the Nikon D40 & D40x, the telephoto effect of a lens is enhanced even further, so even relatively affordable optics can be transformed into powerful super-telephotos.

Lens hood

A lens hood is indispensable for outdoor photography. Attached to the front of the lens via a bayonet, a lens hood prevents light scatter in the lens barrel, which shows in the final image as flare (page 127). Most Nikkor lenses are sold with a compatible lens hood.

Zoom lenses

Zoom lenses provide greater versatility and flexibility than a fixed focal length lens. They are economical – negating the need to purchase several prime lenses – so are a good choice for photographers on a budget. They are also well suited to those who do not want to carry too much heavy equipment, for instance travel photographers. Advances in technology and design have ensured that the optical quality of the best zooms is now comparable to high-quality prime lenses. In the field, zoom lenses allow you to quickly adjust your composition without altering your own position in a way that a fixed focal length lens cannot match.

Macro lenses

A true macro lens should offer a reproduction ratio of 1:1 (lifesize or maximum magnification of 1x) or greater. Macro lenses are designed to overcome the shortcomings of standard lenses, when used for close-up photography. Issues of image quality, focusing and magnification are all addressed by the technology incorporated into a macro lens.

For more on macro lenses and close-up photography in general, see pages 162–171.

Teleconverters

Teleconverters are optical components; not an actual lens. Nikon presently produces three teleconverters of varying strength: the TC-14E II (1.4x), TC-17E II (1.7x) and TC-20E II (2x). When placed between camera and lens, they magnify the focal length of the lens attached by that factor – for example, a 300mm lens coupled with the Nikon TC-14E II 1.4x converter will have an effective focal length of 420mm. The minimum focusing distance of a lens is unaffected. This makes them a handy addition to any photographer's camera bag, as they're a compact, light and an inexpensive method to expand your kit's overall flexibility. Two main disadvantages of using a teleconverter are a slight degradation in image quality and a loss in light. For instance, the TC-14E II will result in a one stop narrowing of the maximum aperture of the lens, the TC-17E II a loss of one and a half stops and

using the TC-20E II will result in an exposure compensation of two full stops. So, in practice, coupling the TC-20E II 2x converter to a lens with a maximum aperture of f/5.6 would effectively make f/11 the widest aperture available to you. When using a teleconverter reduces the maximum aperture to less than f/5.6, the autofocusing system may become unpredictable or even unusable.

> **Tip**
> Teleconverters are incompatible with some Nikkor lenses. Therefore, always read the lens instruction booklet prior to attaching one.

Nikkor lens chart

There are too many Nikkor lenses to mention here, so this list covers those (mostly autofocus) models that are easily available.	Optical features
AF DX Fisheye 10.5mm f/2.8G ED	CRC, D, DX, ED, G, SIC
AF 14mm f/2.8D ED	ASP, D, ED, RF, SIC
AF 16mm Fisheye f/2.8D	CRC, D, SIC
AF 18mm f/2.8D	ASP, D, RF, SIC
AF 20mm f/2.8D	CRC, D, SIC
AF 24mm f/2.8D	CRC, D, SIC
AF 28mm f/2.8D	D, SIC
AF 35mm f/2D	D, SIC
AF 50mm f/1.4D	D, SIC
AF 50mm f/1.8D	D, SIC
AF Micro 60mm f/2.8D	CRC, D, SIC
AF 85mm f/1.4D IF	D, IF, SIC
AF 85mm f/1.8D	D, RF, SIC
PC Micro 85mm f/2.8D	CRC, D, SIC
AF DC 105mm f/2 D	D, DC, RF, SIC
AF-S VR Micro 105mm f/2.8G IF-ED	D, ED, G, IF, M/A, N, SIC, SWM,
AF DC 135mm f/2D	D, DC, RF, SIC
AF 180mm f/2.8D IF-ED	D, ED, IF, SIC
AF-S VR 200mm f/2G IF-ED	D, ED, G, IF, M/A, SIC, SWM, VR
AF Micro 200mm f/4D IF-ED	CRC, D, ED, IF, SIC
AF-S 300mm f/4D IF-ED	D, ED, IF, M/A, SIC, SWM
AF-S VR 300mm f/2.8G IF-ED	D, ED, G, IF, M/A, SIC, SWM, VR

Angle of view	Min. focus distance	Minimum aperture	Repro. ratio	Filter size	Dimensions dia. x length	Weight
180°	0.14m	f/22	1:5	rear	63 x 62.5mm	305g
90°	0.2m	f/22	1:6.7	rear	87 x 86.5mm	670g
107°	0.25m	f/22	1:10	rear	63 x 57mm	290g
76°	0.25m	f/22	1:9.1	77mm	82 x 58mm	380g
70°	0.25m	f/22	1:8.3	62mm	69 x 42.5mm	270g
61°	0.3m	f/22	1:8.9	52mm	64.5 x 46mm	270g
53°	0.25m	f/22	1:5.6	52mm	65 x 44.5mm	205g
44°	0.25m	f/22	1:4.2	52mm	64.5 x 44.5mm	205g
31°30′	0.45m	f/16	1:6.8	52mm	64.5 x 42.5mm	230g
31°30′	0.45m	f/16	1:6.8	52mm	64.5 x 42.5mm	155g
26°30′	0.22m	f/32	1:1	62mm	70 x 74.5mm	440g
18°50′	0.85m	f/16	1:8.8	77mm	80 x 72.5mm	440g
18°50′	0.85m	f/16	1:2	62mm	71.5 x 58.5mm	380g
18°30′	0.39m	f/45	1:2	77mm	83.5 x 109.5mm	770g
15°20′	0.9m	f/16	1:7.7	72mm	79 x 111mm	640g
15°20′	0.31m	f/32	1:1	62mm	83 x 116mm	790g
12°	1.1m	f/16	1:7.1	72mm	79 x 120mm	815g
9°	1.5m	f/22	1:6.6	72mm	78.5 x 144mm	760g
8°	1.9m	f/22	1:8.1	52mm	124 x 203mm	2,900g
8°	0.5m	f/32	1:1	62mm	76 x 193mm	1,190g
5°20′	1.45m	f/32	1:3.7	77mm	90 x 222.5mm	1,440g
5°20′	2.3m	f/22	1:6.4	52mm	124 x 267.5mm	2,870g

	Optical features
AF-S II 400mm f/2.8D IF-ED II	D, ED, IF, M/A, SIC, SWM
AF-S II 500mm f/4D IF-ED II	D, ED, IF, M/A, SIC, SWM
AF-S II 600mm f/4D IF-ED II	D, ED, IF, M/A, SIC, SWM
AF-S DX 12–24mm f/4G IF-ED	ASP, D, DX, ED, G, IF, M/A, SIC,
AF-S 17–35mm f/2.8D IF-ED	ASP, D, ED, IF, M/A, SIC, SWM
AF-S DX 17–55mm f/2.8G IF-ED	ASP, D, DX, ED, G, IF, M/A, SIC,
AF-S 18–35mm f/3.5–4.5D IF-ED	ASP, D, ED, IF, SIC
AF-S DX 18–55mm f/3.5–5.6G ED II	ED, SIC, ASP, D, G, SWM, DX
AF-S DX 18–70mm f/3.5–4.5G IF-ED	ASP, D, DX, ED, G, IF, M/A, SIC,
AF-S DX 18–135mm f/3.5–5.6G IF-ED	ASP, D, DX, ED, G, IF, SIC, SWM
AF-S DX VR 18–200mm f/3.5–5.6G IF-ED	ASP, D, DX, ED, G, IF, M/A, SIC,
AF 24–85mm f/2.8–4D IF	ASP, D, IF, SIC
AF-S VR 24–120mm f/3.5–5.6G IF-ED	ASP, ED, G, IF, SWM, VR
AF 28–70mm f/2.8D IF-ED	ASP, D, ED, IF, M/A, SIC, SWM
AF-S DX 55–200mm f/4–5.6G ED	D, DX, ED, G, SIC, SWM
AF-S DX VR Zoom-Nikkor 55–200mm f/4–5.6G IF-ED	ED, IF, SWM, G, M/A, VR, DX
AF-S VR 70–200mm f/2.8G IF-ED	D, ED, G, IF, M/A, SIC, SWM, VR
AF-S VR 70–300mm f/4.5–5.6G IF-ED	ED, SIC, IF, SWM, D, G, M/A, VR
AF 80–200mm f/2.8 D ED	D, ED, SIC
AF VR 80–400mm f/4.5–5.6D ED	D, ED, SIC, VR
AF VR 200–400mm f/4G IF-ED	D, ED, G, IF, M/A, SIC, SWM, VR

Angle of view	Min. Focus distance	Minimum aperture	Repro. ratio	Filter size	Dimensions dia. x length	Weight
4°	3.5m	f/22	1:7.7	drop-in	159.5 x 351.5mm	4,440g
3°10'	4.6m	f/22	1:8.2	drop-in	139.5 x 394mm	3,430g
2°40'	5.6m	f/22	1:8.6	drop-in	166 x 430.5mm	4,750g
99°–61°	0.3m	f/22	1:8.3	77mm	82.5 x 90mm	465g
79°–44°	0.28m	f/22	1:4.6	77mm	82.5 x 106mm	745g
79°–28°50'	0.36m	f/22	1:5	77mm	85.5 x 110.5mm	755g
76°–44°	0.33m	f/22	1:6.7	77mm	82.5 x 82.5mm	370g
76°–28°50'	0.28m	f/22–38	1:3.2	52mm	70.5 x 74.0mm	205g
76°–22°50'	0.38m	f/22–f/29	1:6.2	67mm	73 x 75.5mm	390g
76°–12°	0.45m	f/22–f/38	1:4.1	67mm	73.5 x 86.5mm	385g
76°–8°	0.5m	f/22–f/36	1:4.5	72mm	77 x 96.5mm	560g
61°–18°50'	0.21m	f/22	1:5.9	72mm	78.5 x 82.5mm	545g
61°–13°20'	0.5m	f/22	1:4.8	72mm	77 x 94mm	575g
53°–22°50'	0.7m	f/22	1:5.6	77mm	88.5 x 121.5mm	935g
28°50'–8°	0.95m	f/22–f/32	1:3.5	52mm	68 x 79mm	255g
28°50'–8°	1m (through entire zoom range)	f/22–32	1:4.3	52mm	73.0 x 99.5mm	335g
22°50'–8°	1.5m	f/22	1:6.1	77mm	87 x 215mm	1,470g
22°50'–5°20'	1.5m	f/32–40	1:4	67mm	80 x 143.5mm	745g
22°–8°	1.5m	f/22	1:7.4	77mm	87 x 187mm	1,300g
20°–4°	2.3m	f/32	1:4.8	77mm	91 x 171mm	1,360g
8°–4°	2m	f/32	1:3.7	rear	124 x 365mm	3,275g

Chapter **7**

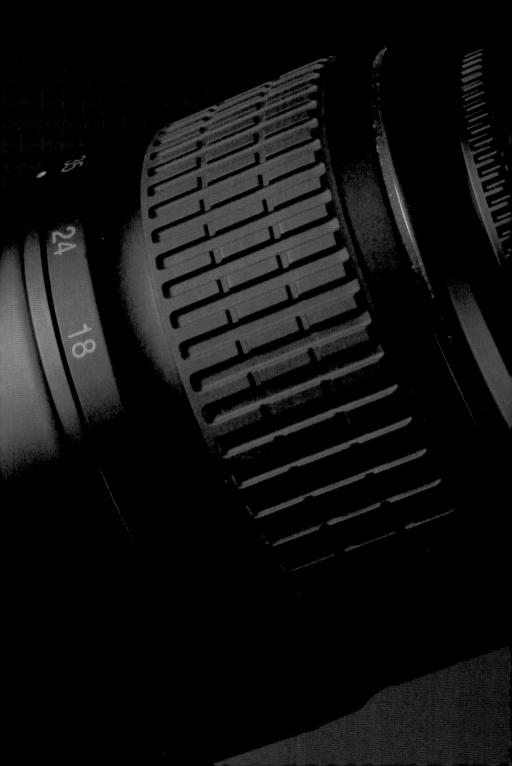

Accessories

The Nikon range of digital SLR cameras, including the D40 & D40x, is compatible with a large number of accessories; some made by Nikon, others produced by independent companies. These accessories can be divided into two main groups: those that affect the final image, such as filters (see below), flash accessories and close-up accessories; and those that affect the performance and handling of the camera.

Filters

Cameras and lenses, no matter how technologically advanced, simply do not see in the same way as the human eye. Whilst our brains are able to adjust quickly to subtle differences in colour and tone, the photographic equipment we use often needs a helping hand to record the world as we see it.

There will also be times when reality doesn't quite match the image you hold in your mind's eye. In such instances, you might wish to make subtle adjustments for creative effect, for example, to warm up the appearance of a cool looking landscape. Regardless of whether your aim is to record a scene authentically, or enhance certain attributes, filtration is often the answer. Although a number of traditional filters have been made redundant by digital technology, some optical in-camera filters continue to be important tools for image correction and enhancement.

Made of glass, plastic or resin, filters are available in two types: circular ones, which simply screw into the lens filter mount; or the square/rectangular type, which slot into a specific filter holder that is attached to the front of the lens. While many argue that the square system offers more long-term flexibility, screw-in filters remain popular with beginners.

Nikon, along with independent filter makers like Hoya, Lee, Cokin and B+W, produces an extensive range of filters to suit a variety of shooting situations.

True to Nikon's heritage of optical engineering, the glass which is used in its filters is designed and manufactured to high standards. Round, screw-fit filters are produced in a variety of sizes in order to fit different lens diameters – the filter diameter of your lens will be written in millimetres on the front of the lens barrel after the Ø symbol.

Drop-in and rear gelatin filters

Owing to the sheer size of the front element of some long telephoto and wideangle lenses, manufacturers often resort to using drop-in or rear gelatin filters. As with screw-in filters, the diameter of a drop-in filter is still important. But instead of placing the filter in front of the lens, it is 'dropped in' to a specially designed slot in the lens barrel. Some filters require gelatin filter sheets to be cut to size; these can then be slotted into a rear holder on the mount. (See pages 186–189 for Nikkor lenses that require rear or drop-in filters.)

DAFFODIL AND POLARIZED SKY Some optical filters, such as a polarizer, continue to play a significant role in digital photography. They reduce reflective glare, saturating colour. Their effect cannot be replicated using post-processing techniques.

UV and skylight filters

If you can only afford to buy one filter, prioritize a skylight or UV. Both these filters absorb ultraviolet light, cutting out the blue cast experienced at high altitudes and reducing atmospheric haze – skylight filters also have a slightly warming effect. Despite these benefits, photographers most commonly use these filters as a cheap method to protect the front element of the lens. It is perfectly OK to keep a UV or skylight filter screwed on at all times, but remember to check it regularly for dust and scratches.

Polarizing filters

Available in two types – circular or linear – polarizing filters are round filters. Owing to the way autofocus digital SLRs work, a circular polarizer is the only option for D40 & D40x users. Nikon produces a PL-C filter available in 52mm, 58mm, 62mm, 67mm, 72mm and 77mm fits. Third-party filters are also available from manufacturers such as Hoya and Sigma.

Polarizers have three main functions: to deepen blue skies and saturate colour; to reduce glare on non-metallic surfaces and to eliminate reflections from water

SANDY BEACH
Photographers often utilize a skylight or UV filter to protect the front element of their lens from dust, dirt, spray, scratches and sand.

and glass. Polarizers perform best in early morning or late afternoon, and they are most effective at a 90° angle to the sun. To eliminate reflections try to keep the angle between the lens axis and the reflective surface at around 30°. Bear in mind though that the strongest effect is not always the best, so rotate the polarizer while looking through the viewfinder; that way you can watch the effect and stop rotation before it looks too artificial.

When used in bright, sunny conditions, a polarizer can give the final image a slight blue cast, so be careful to adjust your white balance setting accordingly (page 79).

BRENTOR CHURCH, DARTMOOR, DEVON
A polarizing filter is a 'must-have' accessory for landscape photographers in particular. In this instance, the filter has intensified the colour of the clear blue sky, increasing the picture's impact.

Colour-correction filters

Warm-up and cool-down filters for correcting or enhancing colour tones have now been rendered largely redundant. This is because digital photographers are able to control the colour balance of the image via the camera's white balance setting.

Neutral-density filters

There are two types of neutral-density (ND) filter: plain and graduated. An ND filter acts by reducing the intensity of light entering the lens, forcing an exposure increase without altering the colour balance of the final image. This filter is often used when a slow shutter speed or wide aperture is required in bright conditions and you are already at your minimum ISO rating.

ND filters come in a variety of strengths, often referred to as the 'filter factor'. This is commonly indicated in multiples, with a 0.3 ND being equivalent to a reduction of one full stop of light; a 0.6 ND by two and so on. Nikon produces a range of five ND filters; ND2S, ND4, ND4S, ND8S and the ND400.

ND graduated filters are designed so that the top half is coated and the bottom half is clear, with a transitional zone in between. These filters are designed to balance the contrast between the bright sky and darker foreground, allowing photographers to expose both correctly. It is important to position the coated area carefully when composing your shot, so that the transitional zone meets the horizon. Although Nikon does not produce graduated neutral-density filters, they are readily available from third-party manufacturers like Lee and Cokin – a 0.6 ND grad is a particularly useful filter to own.

Special effect filters

All filters should be used with care and restraint, but even more so if you are using some form of 'special effect' filter.

Many are available, but the two most common are the soft-focus filter and the starburst filter. While soft-focus filters may add atmosphere and flatter skin tones, the effect can also look dated and can detract from the subject; moderation is the key. Similarly, starburst filters can produce novel effects when used sparingly.

Nikon produces two soft-focus filters: No.1 and No.2. No.1 is suited to portraits, giving images a 'romantic haze', while the No.2 version is stronger, producing a fog-like effect. The No.1 version is available in 52mm, 62mm, 72mm and 77mm mounts, while the No.2 version is available in 52mm, 62mm and 72mm mounts.

In the box

Rechargeable Li-ion battery EN-EL9

Although the D40 & D40x are very easy on battery life, it is always advisable to keep a fully charged spare with you at all times – especially in cold conditions when battery life can be greatly reduced.

Quick charger MH-23

The MH-23 quick charger connects to a household electricity supply and charges the EN-EL9 Li-ion battery.

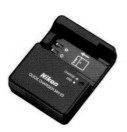

BF-1A body cap

The BF-1A keeps the mirror, viewfinder screen and low-pass filter free of dust and dirt when there isn't a lens attached.

Strap AN-DC1

A strap allows the D40 or D40x to be carried hands free and minimizes the likelihood of it being accidentally dropped.

Rubber eyecup DK-16

Rubber eyecup for comfortable viewing – also compatible with the D70.

Eyepiece cap DK-5

When using the self-timer option, or remote release, it is recommended to remove the DK-16 rubber eyecup and attach the DK-5 eyepiece cap. This will prevent stray light from entering the viewfinder and affecting the exposure in auto exposure modes.

USB cable UC-E4

Data cable (USB) to connect the D40 or D40x to a computer – approx 1.5m in length.

PictureProject

PictureProject is an easy-to-use software package that lets you effortlessly organize, view, retouch or share the pictures you take with your digital camera.

Other accessories

Nikon also produces an impressive array of dedicated accessories, which can prove useful in a variety of shooting situations. Some of the most useful are listed here.

ML-L3 remote release
The ML-L3 infrared remote control makes it possible to release the shutter from a distance. The remote control can be used to capture self-portraits and also prove useful to prevent camera shake during shutter release.

Semi-soft camera case CF-DC1
The CF-DC1 semi-soft, ever-ready camera case will help protect your camera from the weather and light knocks. As your lens collection develops, you might consider using a CF-EU01 system bag or a rucksack-style camera bag, for added protection and comfortable transportation.

System bag CF-EU01
This black polyester system bag will house your Nikon digital SLR along with lenses, speedlight, batteries, etc. The inside of the bag is cushioned, the main section has adjustable Velcro compartments and the shoulder strap has a rubbery patch to help prevent it from slipping from your shoulder.

EH-5 AC adaptor
This can be used to power the D40 or D40x from a household power supply and is recommended when using the camera for extended periods. Its rated input is AC 100–240VAC, 50/60hz. Separate power cables are available for use in North America, the UK, continental Europe, Australia and Japan.

AC adaptor connector EP-5
When connected to the AC adaptor EH-5, the EP-5 connector allows you to power the camera directly by simply inserting the power connector into the battery chamber.

DG-2 magnifier
The DG-2 gives 2x magnification of the central portion of the viewfinder; ideal for focusing. It is attached via an eyepiece adaptor.

Right-angle viewfinder DR-6

This right-angle viewing attachment can be attached to the finder of Nikon digital SLR cameras. With this attachment, the viewfinder image is viewed at right angles (via the built-in roof prism) to the camera's optical axis – a feature that is very convenient when shooting from low (or high) viewpoints, or when normal finder viewing is proving difficult, as is often the case when shooting close-up subjects.

Memory cards

Secure Digital (SD) cards are one of the most popular types of camera memory. Many independent manufacturers produce suitable memory cards, but Nikon recommends SanDisk and Lexar media for reliability.

SD cards are designed with a useful 'write protect' switch to prevent accidental loss of data. When this switch is in the 'lock' position, the camera will play a message to warn photographs can not be recorded or deleted and the memory card cannot be formatted.

Nikon Capture NX

Capture NX is a revolutionary image-editing application designed specifically for digital photographers irrespective of their chosen file format. The software makes

refined image enhancement a simple process, regardless of their level of expertise. Powerful, yet simple to use, this program allows changes to be made to specific areas of an image via a simple point and click – negating the need for complex masking or layering techniques. Additional dedicated tools are available for those shooting in NEF (RAW) file format.

The original image data within the file is always preserved allowing an infinite number of variations to be created and stored without the need to make duplicates of the original data – a feature that saves enormous amounts of disk space.

Portable storage devices

When in the field for a prolonged period of time many photographers use portable storage devices to temporarily hold, review or back up their work. Ideally, opt for a device with a hard drive of 40GB or more and a review screen. These devices allow you to download, organize and view images easily. Most support a number of formats and are compact enough to be carried in your camera bag.

Nikon did release its own version – the Coolwalker MSV-01 – but this has been discontinued.

Chapter 8

Connecting to an external device

There are three main reasons for connecting your camera to an external device: to manage, display and to print your images. Thanks to the camera's user friendly design, connecting the Nikon D40 & D40x is straightforward; everything you require is included in the box.

Connecting to a TV

1) Select the appropriate video mode from Video mode in the setup menu (page 94).

2) Ensure that both the camera and the television are switched off.

3) Open the connector cover protecting the Video connector, Reset switch and USB connector. Attach the EG-D100 video cable (supplied separately) to the video connector socket on the camera before connecting it to the video-in socket of the television.

4) Switch the television on and tune the television to the video channel.

5) Switch the camera on. Press the ▶ button to begin playback. During playback, images will be displayed on the television or recorded to video tape.

THE D40
Owing to its user-friendly design, it is simple to connect the Nikon D40 & D40x to external devices, like a TV or computer.

Note
The camera monitor will remain off while playing images through the TV. You can navigate through the playback system in the same way as you would normally when using the camera's LCD monitor. If you are planning to view or record a number of images via the television, then use the (optional) EH-5 AC adaptor to ensure power is retained for normal operation afterwards. On some televisions, the edges of the pictures may not be visible when photographs are viewed on screen.

Connecting to a printer

The D40 & D40x are compatible with the PictBridge industry standard. This means images can be printed directly from the camera to an attached printer (that also supports PictBridge) without using a computer first.

1) In the setup menu, set the USB option to PTP (see page 96). Turn the printer on and the camera off. Connect the supplied UC-E4 USB cable, first to the USB connector on the D40 & D40x and then directly to the printer – do not connect via a USB hub or the keyboard.

2) Turn the camera on. A welcome message will appear, followed by the PictBridge display. You can now proceed to 'Printing photographs one at a time' or 'Printing multiple photographs'.

Printing pictures one at a time

Direct printing is remarkably simple and intuitive. You can simply select the images that you wish to print, set a few straightforward parameters and start printing, all from the back of the Nikon D40 or D40x.

1) To create a print of the photograph selected in the PictBridge playback display, press the **OK** button. Using the multi-selector, highlight and select from the options set out in the table on page 204.

Notes

Press the multi-selector left or right to view additional photographs or press and hold the ⊕ button to zoom in on the current photo. To view six thumbnail images at one time, press the ⊖ button.

Only images captured in JPEG format can be printed directly from the camera. NEF (RAW) photographs must first be transferred to a computer and processed using PictureProject, Capture NX or an independent RAW converter before being printed.

When taking pictures for direct printing, select Ia (sRGB) or IIIa (sRGB) – in P, S, A or M modes – for the colour mode via the Optimize image menu to maximize image quality in-camera.

Printing options

Setting	Option details
Page size	Using the multi-selector, highlight and select the option required: Printer Default (the default page size for the printer attached), 3.5 x 5in, 5 x 7in, 100 x 150mm, 4 x 6in, 8 x 10in, Letter, A3 or A4.
No. of copies	Press the multi-selector up or down to choose the number of copies (the maximum number is 99), then highlight and select it to return to the print menu.
Border	Using the multi-selector, highlight and select the option required: Printer Default (the default setting for the printer attached), Print with Border (print the photo with a white border) or No Border.
Time stamp	Using the multi-selector, highlight and select the option required: Printer Default (default setting for the printer attached), Print Time Stamp (print the time and date the photo was taken on the photo) or No Time Stamp.
Cropping	Using the multi-selector, highlight and select the option required: Crop or No Cropping. When Crop is selected, a cropping dialog box will be displayed. Use the ⊕ and ⊖ buttons to toggle the size of crop and the multi-selector to choose the position of the crop. Press **OK** to return to the print menu.
Printing	Finally, to start printing, highlight and select Start printing. The Pictbridge playback display will be shown when printing is complete.

CROPPING
Cropping your image before printing can help strengthen the composition and impact of an image.

Printing multiple pictures

To print multiple selected pictures or to create a useful index print listing all JPEG images as thumbnails, press the **MENU** button in the PictBridge playback display. Using the multi-selector, highlight and make selections from the options on page 206.

To safely disconnect the D40 & D40x from your printer, you should first turn the camera off and then the printer. Finally, detach the cable.

Notes
Although NEF (RAW) images will be displayed in the print select menu, they cannot be selected for printing.

If an error occurs during printing, the camera will display the dialog 'PRINT ERROR'. After checking the printer, use the multi-selector to highlight and select Continue, to resume printing, or Cancel to exit without printing the final pages.

Print select	This will display the print select menu. Scroll through images, pressing the ⊕ button to display current picture full screen. Select picture and set number of prints (the maximum is 99) by pressing the multi-selector up. Selected pictures will be marked by a 🖺 icon. Pictures can be deselected by pressing the multi-selector down when the number of prints is set to 1. Repeat to select additional images. You can then display print options: choose page size, border and time stamp options as described on page 204. To begin printing the selected images, highlight and select Start Printing in the PictBridge setup menu. The PictBridge menu will be displayed when printing is complete.
Print (DPOF)	This option prints current DPOF (Digital Print Order Format) print order. DPOF date and data imprint options are not supported when printing via direct USB connection. To print the date of recording on photographs in the current print order, use the PictBridge Time stamp option. This option cannot be used if there is insufficient space on the memory card to store the print order.
Index print	This option creates an index print of all JPEG photos to a maximum of 256. Press the **OK** button to display the index print setup menu. Using the multi-selector, choose page size, border and time stamp options as described on page 204. To start printing, highlight and select Start Printing in the PictBridge setup menu. The PictBridge menu will be displayed when printing is complete.

Connecting to a computer

The Nikon D40 & D40x can be connected to either a Mac or PC via the UC-E4 USB cable supplied. Using the supplied PictureProject software, images can be downloaded from the camera to your computer where they can then be viewed, edited and stored. The camera can also be used in conjunction with Nikon Capture NX (available separately), which boasts a variety of advanced post-processing features.

Your computer must have a USB port and naturally needs a CD-Rom drive in order to install the software.

Before connecting the camera

After reviewing the system requirements and reading the software manuals, install PictureProject from the supplied installer CD. Then select one of the following USB settings:

Windows XP Home editions, Windows XP Professional or Mac OS X (version 10.3.9 or later) – select PTP or Mass Storage

Microsoft Vista

The D40 & D40x are Nikon's first cameras to be certified for use with Vista, ensuring it delivers the highest quality images and photo-sharing capabilities with Microsoft's latest version of Windows. As a result, using the Nikon D40 or D40x in combination with Vista makes it easier to capture, organize and share pictures with family and friends.

Windows 2000 Professional – select Mass Storage

Tip
Do not turn the camera off or disconnect the USB cable while transfer is in progress. To ensure data transfer isn't interrupted, check that there is sufficient battery power remaining before you begin downloading to an external device. Alternatively, connect the camera to a mains power outlet using the optional EH-5 AC adaptor.

Note
If PTP is selected in conjunction with Windows 2000 professional, the Windows hardware wizard will be displayed. Click cancel to exit the wizard and then safely disconnect the camera. Select Mass Storage before reconnecting the camera.

Connecting the camera

1) Switch the computer on and wait for it to complete its start-up process. Ensure that the D40 or D40x is turned off, before attaching the supplied UC-E4 USB cable to the USB connector on the side of the camera. Fit the other end of the cable directly to your computer via a free USB port.

2) Switch the camera on. If you have selected Mass Storage for the USB connection, the monitor and viewfinder will display the message 'Connecting to PC'. If PTP is selected, the normal shooting indicators will be displayed.

Note
When connecting the USB cable, never use force or attempt to insert the connectors at an angle.

3) When you switch the camera on, the computer will automatically detect the camera and display the PictureProject transfer.

4) Select a destination folder – on your computer's hard disk drive – to transfer the pictures into. Once download is complete, it is safe to disconnect the camera.

Tip
If you want to download the images on your camera without connecting it directly to a computer, use a card reader to read the memory card. This will appear as an external drive and image files can be downloaded from the reader in the usual way.

PICTUREPROJECT
Once file download is complete, your images will be displayed as thumbnails in the PictureProject software.

If PTP is selected for USB, it is fine to switch off the D40 or D40x and disconnect the UC-E4 USB cable once the transfer of images is completed.

If Mass Storage is the selected USB menu option, then the camera must first be removed from the computer system using one of the following steps:

Windows XP Home and Windows XP Professional editions
In the computer's taskbar, click the Safely Remove Hardware icon and then choose 'Safely Remove USB Mass Storage Device' from the subsequent menu.

Windows 2000 Professional
In the computer's taskbar, click the 'Unplug or Eject Hardware' icon and then choose Stop USB Mass Storage Device from the subsequent menu.

Mac OS X
Using the mouse, drag the Nikon D40 or D40x icon into the trash.

Once you have taken the appropriate step for your operating system – as outlined above – you can then switch the camera off and remove the UC-E4 USB cable from both the computer and the camera.

Tip
Never turn off or disconnect the camera whilst image transfer is in progress.

DISCONNECTING
It is important to disconnect the camera properly in order to avoid corruption.

Nikon Software

The D40 & D40x are bundled with PictureProject editing software. It is designed to be accessible to beginners and experienced users alike. PictureProject includes a number of useful digital image-enhancement tools, which are easy to understand and apply. Using the editing tools, you can, among other features, make fine adjustments to image brightness, boost colour, straighten images and also sharpen your photographs. To realize the program's full editing and processing potential, it is recommended you read the PictureProject reference manual – supplied on CD with the D40 & D40x. However, here is a brief guide to editing images via the software.

Disconnecting the camera

1) Double click the image you wish to edit from the thumbnail display of imported images in the PictureProject software's Organize dialogue box. This will transfer the image to Edit.

2) To the right of the image is a palette of editing tools. Highlight an option from the Photo Enhance box.

Note
If saving a processed NEF (RAW) as a JPEG file, it is best to save it at the highest quality setting. A high compression ratio will diminish picture quality and is best used only when you wish to send an image via email.

3) Adjust the selected parameter using the subsequent tool which will appear underneath.

4) You can zoom in and out of images and also crop, rotate and reduce the effects of red eye, using the toolbar above the image being edited.

5) The image will update as you alter the settings, allowing you to judge the alterations that you are making as you do so. You can reset them if necessary. More than one parameter can be applied to the same image.

6) Once editing is complete, click File>Export JPEG/TIFF. From the resulting Export Photos dialogue box, select the file type you require (and quality if JPEG is selected) and click Export. Select destination file and click Export again.

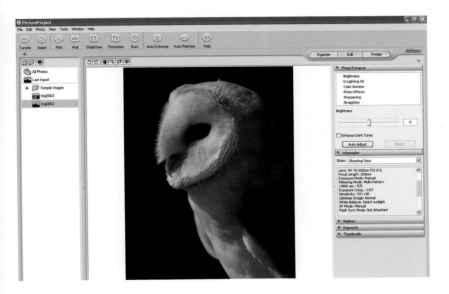

EDITING
Making fine adjustments to images is easy using the PictureProject software supplied with the D40 & D40x.

Using third-party software

The industry standard image-manipulation software is Adobe Photoshop. The majority of photographers, whether amateur or professional, use either a full or limited version of this program. To cover all the creative and corrective possibilities of such a complex and versatile program requires a dedicated manual. The software supplied with the Nikon D40 & D40x is adequate for fine-tuning images and adjusting the basic shooting parameters. However, as you wish to achieve more from your digital images, it is worth investing in a version of Photoshop. The latest version (Photoshop CS3) is pricy, so unless your budget will allow, opt for a limited version – it should prove more than adequate. Recent versions of both the full and limited versions of Photoshop include a plug-in called Adobe Camera RAW, which is many photographers' preferred way of converting RAW files. To update existing software, download the latest plug-ins to support the D40 & D40x's NEF files from www.adobe.com.

Chapter **9**

Caring for the Nikon D40 & D40x

Nikon cameras are renowned for their build quality and whilst the D40 & D40x are aimed at the entry level and amateur market, they are designed to withstand the rigours of regular use. Having said that, heat, dust, high humidity, cold and neglect can all damage a digital SLR. However, by simply taking a few logical precautions, you will help to ensure a long life for your camera.

Basic care

Using a blower to remove dust from the eyepiece, mirror and lens is ideal, but, owing to its delicate nature, the CCD image-sensor requires extra caution. Never try to clean it with a blower brush, cloth, canned air or your fingers. Don't touch the electrical contacts on the camera or lens, and the delicate shutter curtains. The front of your lens can be protected by a skylight or UV filter (page 194), but keep a lens cap on when not in use.

Once clean, keep the camera cool and dry at all times to prevent mould or mildew; do not store the camera with naphtha or camphor moth balls. If you are unlikely to use it for a month or more, remove the EN-EL9 battery pack, and occasionally trigger the shutter to keep the mechanics moving. Store it in a well-ventilated place away from the sun, radiators or any other source of heat. Avoid storing the camera anywhere there are corrosive chemicals present (a darkroom, for example). Finally, do not leave the D40 or D40x near anything emitting a strong magnetic field, or strong radio waves – doing so may result in malfunction or loss of image data. When you take your camera out of storage, it is sensible to check each control in turn before taking important photos.

Tip
When changing lenses, hold the camera so it is facing downwards. This will minimize the dust entering the camera body and lodging on the low-pass filter. An alternative to having the low-pass filter cleaned is to remove the marks manually during post-processing. This can be done quickly by using the clone tool or healing brush in photo editing software like Photoshop.

SEASIDE
Tiny particles of dust or dirt can create huge problems for your camera's sensor. Knowing how to minimize and deal with it is important. Sand can prove especially damaging – so bear this in mind when you next visit the beach with your camera.

Cleaning the sensor

Photo-sensors are prone to dust and dirt attracted by the electromagnetic properties of the CCD. Although the D40 and D40x's sensors are partly protected by the low-pass filter, dust and foreign matter settling on the filter will appear as dark specks on your images. To prevent this from happening, it may be necessary to clean the area. This is best done by a Nikon-approved technician, but should you choose to do this yourself it is important to remember that the sensor and low-pass filter are extremely delicate components and should be treated with great care. To clean the sensor, first remove the lens, switch the camera on and select the mirror lock-up function from the setup menu (page 98). Fully depress the shutter-release button to raise the mirror and open the shutter curtain, revealing the low-pass filter. When

performing this operation, it is advisable to use an EH-5 AC adapter (page 198) to prevent the camera from running out of power mid-clean. If you are using an EN-EL9 battery pack. make sure that it is fully charged. To clean the filter, hold the camera facing downwards so the dust can fall out while using a blower (not a brush). Be careful not to touch the low-pass filter.

⚠ Common errors
The Nikon D40 & D40x are precision instruments and may malfunction if subjected to physical shock. In the unlikely event of the camera's casing splitting, due to being dropped from height, do not touch any of the internal workings – doing so may result in an electric shock.

Coping with the cold

When subjected to temperatures below freezing, the lifespan of the camera's batteries will be greatly reduced – or they may even become inactive in extreme conditions. The mechanics of the camera may also become sluggish or cease to operate altogether. Keep your camera close to your body, and only remove it when you are ready to take a picture. Keep spare batteries warm in your pockets, or close to your body.

Heat and humidity

Heat and high humidity can cause camera parts to warp and lubricating oils to leak. Transporting your camera from a cool environment, such as an air-conditioned room, into humid conditions, or vice versa, leads to condensation within the lens, which can cause a malfunction or, at the very least, encourage mould and fungus. To prevent this,

place each item in a plastic bag or airtight container and add sachets of silica gel before resealing. The condensation will form on the bag and not on the photographic equipment. Allow the bag to reach the ambient temperature before removing the camera and if any condensation appears on the camera stop using it, remove the lens, memory card and battery. Allow the condensation to evaporate before shooting.

Water protection

While it will withstand the odd shower and moisture, don't expect the D40 or D40x to survive a dip in a pond or river. If any water should

WINTER WEATHER
Expect the lifespan of the Nikon battery to be reduced in chilly weather. Always carry a fully charged spare.

splash onto your equipment, wipe it with a clean, dry cloth immediately. Exposing your camera to saltwater, is more serious and can lead to corrosion and the malfunction of certain electronic components. To limit the damage, ensure that you wipe the camera with a well-wrung wet cloth as soon as possible.

If you are likely to use your equipment in wet conditions use a fitted plastic cover over the camera and lens barrel, or protect your kit with a plastic bag. If you should happen to drop the camera in water, or if water should enter the camera in any way, remove the battery pack to prevent fire or electrical shock, and contact your nearest authorized Nikon dealer as soon as possible.

Dust protection

When taking pictures in a dusty or sandy environment, thoroughly clean your equipment on your return home; a few squirts of compressed air should clear the lenses' and camera's exterior.

Finally, do not attempt any maintenance other than that outlined in the camera's manual – if in doubt, contact an authorized dealer or service centre. Never disassemble the camera yourself.

Card care

Treat your memory cards with the same care as you do your camera – if you drop them or subject them to vibration, it may damage them and the images they contain. Similarly, do not expose cards to direct sunlight, dusty environments or excessive heat, keep them away from liquids and, when not in use, protect them by keeping them stored in their supplied, purpose-built plastic cases. Memory cards should not be stored on or near anything producing a strong magnetic field – such as a television set or stereo speakers – or places prone to static electricity. Keeping memory cards in these conditions may result in loss of image data.

Tip
Lenses attract dust in areas of low humidity. To reduce the effects of static electricity, the cause of this condition, use an anti-static brush. Never apply cleaning solution directly to the lens; instead apply it to the cleaning cloth. Use a gentle circular motion when cleaning optics with a microfilm cloth, and never use solutions not designed for lens cleaning, including those designed for eyeglasses, to clean your equipment – doing so may cause fire or a health hazard.

Glossary

Aberration An imperfection in the image, caused by the optics of a lens.

AE (autoexposure) lock A camera control that locks in the exposure value, allowing an image to be recomposed.

Angle of view The area of a scene that a lens takes in, measured in degrees.

Aperture The opening in a camera lens through which light passes to expose the CCD sensor. The relative size of the aperture is denoted by f-numbers.

Artefact Incorrectly interpreted data, or data produced by the sensor that results in visible flaws in the image.

Autofocus (AF) A through-the-lens focusing system allowing accurate focus without the user manually focusing the lens.

Bracketing Taking a series of identical pictures, changing only the exposure, usually in half or one stop (+/−) increments.

Buffer The in-camera memory of a digital camera that processes the data from the CCD.

Burst size The maximum number of frames that a digital camera can shoot before its buffer becomes full.

CCD (charge-coupled device) A light-sensitive chip made up of a grid of photo-diodes and their associated pixel arrays.

Centre weighted metering A metering system that determines the exposure by placing importance on the reading at the centre of the frame.

Chromatic aberration The inability of a lens to bring the colours of the spectrum into perfect focus at a single point.

Colour temperature The colour of light emitted from a source expressed in degrees Kelvin (K).

CompactFlash card A digital storage card offering safe, reliable storage in a number of different capacities.

Compression The process by which digital files are reduced in size.

Contrast The range between the highlight and shadow areas of an image, or a marked difference in illumination between colours or adjacent areas.

Depth of field (DOF) The amount of an image that appears acceptably sharp from foreground to background. This is controlled by the aperture, the focal length and the camera-to-subject distance.

Dioptre Unit expressing the power of a lens.

dpi (dots per inch) A measure of the resolution of a printer.

Dynamic range The range from shadows to highlights in which the camera can record detail.

Exposure The amount of light allowed hitting the CCD. The amount required depends on the ISO while the amount admitted is controlled by aperture and shutter speed.

Exposure compensation A control that allows changes to be made from the recommended exposure.

Extension rings Hollow tubes that fit between the camera body and lens, used to allow greater magnifications for close-up work.

Fill-in flash Flash combined with daylight in an exposure. Used with naturally backlit or harshly side-lit or top-lit subjects to prevent silhouettes or very dark shadows forming.

Filter A piece of glass or plastic placed in front of, within or behind the lens.

f-number Number assigned to a particular lens aperture. Wide apertures are denoted by small numbers such as f/2; and small apertures by large numbers such as f/22.

Focal length The distance in millimetres from the optical centre of a lens to its focal point.

Focal length multiplication factor The CCD sensor of the D40 & D40x is smaller than a 35mm film frame. As a result, the effective focal length of the lens is multiplied by 1.5x.

fps (frames per second) The rate at which a digital camera is able to process one image and be ready to shoot the next.

Histogram A graph used to represent the distribution of pixel tones in an image, ranging from pure black to pure white.

Hotshoe An accessory shoe with electrical contacts that allows synchronization between the camera and a flashgun.

Hotspot A light area with a loss of detail in the highlights.

Incident-light reading A meter reading based on the light falling on the subject.

Interpolation A way of increasing the size of a digital image by creating pixels based on existing information.

ISO (International Standards Organization) The sensitivity of the CCD sensor is measured in terms equivalent to the ISO rating of a film.

JPEG (Joint Photographic Experts Group) A compressed image file standard. JPEG compression can reduce file sizes to about 5% of their original size.

LCD (liquid crystal display) The flat screen on a digital camera that allows the user to review digital images and access the menu.

Macro A term used to describe close focusing and the close-focusing ability of a lens.

Megapixel One million pixels equals one megapixel.

Memory card A removable storage device for digital cameras.

Microdrives Small hard disks that fit in a CompactFlash slot.

Mirror lock-up A function that allows the reflex mirror of a digital SLR to be raised and held in the 'up' position, to reduce vibration or to clean the sensor.

NEF (Nikon electronic format) Nikon's own RAW file format.

Noise Coloured image interference caused by stray electrical signals.

PictBridge The industry standard for sending information for printing directly from a camera to a printer, without having to connect via a computer.

Pixel Abbreviation of 'picture element'. Pixels are the smallest bits of information that combine to form a digital image. They are laid out in a grid on the sensor, the higher the number of pixels, the higher the resolution of the digital picture.

ppi (pixels per inch) A measure of the resolution of a digital image.

Predictive autofocus An autofocus system that can continuously track a moving subject.

RAW A RAW file contains image parameters appended to the image rather than processed into it. This allows easier post-processing. Nikon's RAW files are in NEF format.

Red-eye reduction A system that causes the pupils of a subject to shrink by shining a light prior to taking the flash picture, thereby reducing the risk of red-eye.

Resolution The number of pixels used to either capture an image or display it, usually expressed in ppi. The higher the resolution, the finer the detail.

RGB (red, green, blue) Computers and other digital devices, including the D40 & D40x, understand colour information as shades of red, green and blue.

Rule of thirds A compositional device that places the key picture elements at points along imagined lines dividing the frame into thirds.

Shading The effect of light striking an image-sensor at anything other than right angles is to lose optical resolution.

Shutter The mechanism that controls the amount of light reaching the sensor by opening and closing to expose the sensor when the shutter-release button is pressed.

SLR (single lens reflex) A type of camera (such as the D40 or D40x) that allows the user to view the scene through the lens in the viewfinder, via a reflex mirror.

Speedlight Nikon's range of dedicated external flashguns are called speedlights.

Spot metering A metering system that takes its reading from the light reflected by a very small portion of the scene.

Teleconverter A lens that is inserted between the camera body and main lens, increasing the effective focal length and therefore the magnification of the subject.

Telephoto lens A lens with a large focal length and a narrow angle of view.

TTL (through the lens) metering A metering system built into the camera that measures light passing through the lens at the time of shooting.

TIFF (Tagged-Image File Format) A universal file format supported by virtually all paint, image-editing and page-layout applications.

USB (universal serial bus) A data transfer standard, used by the D40 or D40x when connecting to a computer.

Viewfinder An optical system used for composing the frame and ensuring that the subject is in focus.

White balance A function that compensates for different colour temperatures in order to allow the correct colour balance to be recorded for any given lighting situation.

Wideangle lens A lens with a short focal length and a wide angle of view.

Useful websites

NIKON

Grays of Westminster
Nikon-only dealer.
www.graysofwestminster.co.uk

Nikon Worldwide
Home page for the Nikon Corporation.
www.nikon.com

Nikon UK
Home page for Nikon UK.
www.nikon.co.uk

Nikon USA
Home page for Nikon USA.
www.nikonusa.com

Nikon Electronic Imaging Products
European user support.
www.europe-nikon.com/support

Nikon Historical Society
The history of Nikon and Nikon products.
www.nikonhs.org

Nikon Imaging Corporation
Official Worldwide imaging site.
www.nikonimaging.com/global

Nikon Info
Nikon user forum and gallery.
www.nikoninfo.com

Nikon Links
Links to a variety of Nikon-related sites.
www.nikonlinks.com

GENERAL SITES

Digital Photography Review
Digital camera reviews, buyers' guides and
digital image comparisons.
www.dpreview.com

ePHOTOzine
Online magazine with a photographic
forum, features and monthly competitions
www.ephotozine.co.uk

Ross Hoddinott
Landscape and natural history
photography.
www.rosshoddinott.co.uk

EQUIPMENT

Adobe
Photoshop and other programs
www.adobe.com

Lexar
CompactFlash cards
www.lexar.com

SanDisk
CompactFlash cards
www.sandisk.com

PHOTOGRAPHY PUBLICATIONS

**Photography books, Black & White
Photography magazine, Outdoor
Photography magazine**
www.pipress.com

Index

About the author

Ross Hoddinott is one of the leading photographers of the natural world. Since winning the junior section of the BBC's *Countryfile* competition in 1991, and going on to win the BBC Young Wildlife Photographer of the Year award in 1995, Ross has forged a successful career shooting both commissions and stock images.

His work is familiar to readers of many magazines, including *Outdoor Photography*, *Practical Photography*, *BBC Wildlife* and many more. His two previous books, *Digital Macro Photography* and *The PIP Expanded Guide to the Nikon D200*, are also published by PIP Publications.

Acknowledgements

Thank you mum, dad and Fliss for all your endless support, encouragement and patience – you are very special. Thanks Evie, my beautiful baby daughter, for all your laughter and smiles. Also, thank you Jon Piper for being such a great friend to me.

Once again, thanks to everyone at PIP for the opportunity to write for you; it is always a pleasure working with such a great team. Lastly, a big thank you to James Beattie and Rachel Netherwood for all your hard work editing this book.

Contact us for a complete catalogue, or visit our website:
PIP, Castle Place, 166 High Street, Lewes, East Sussex BN7 1XU, United Kingdom
Tel: 01273 488005 Fax: 01273 402866
www.pipress.com